305.409 VAN
Vanhouten, Elizabeth
Women in the Japanese World

| DATE DUE | BORROWER'S NAME |
|---|---|
|  |  |
|  |  |
|  |  |

305.409 VAN
Vanhouten, Elizabeth
Women in the Japanese World

# WOMEN IN THE JAPANESE WORLD

# WOMEN'S ISSUES: GLOBAL TRENDS

Women in the Arab World

Women in the Japanese World

Women in the World of Africa

Women in the World of China

Native Women in the Americas

Women in the World of India

Women in the Eastern European World

Women in the World of Southeast Asia

Women in the Hispanic World

Women in the World of Russia

Women in the Mediterranean World

Women in North America's Religious World

# WOMEN'S ISSUES: GLOBAL TRENDS

## WOMEN IN THE JAPANESE WORLD

BY
ELIZABETH VAN HOUTEN

Mason Crest Publishers
Philadelphia

Mason Crest Publishers Inc.
370 Reed Road
Broomall, Pennsylvania 19008
(866) MCP-BOOK (toll free)

Copyright © 2005 by Mason Crest Publishers. All rights reserved. No part of this publication may be reproduced or transmitted in any form or by any means, electronic or mechanical, including photocopying, recording, taping, or any information storage and retrieval system, without permission from the publisher.

First printing.
1 2 3 4 5 6 7 8 9 10
ISBN 1-59084-859-4
ISBN 1-59804-856-X (series)

Library of Congress Cataloging-in-Publication Data

Van Houten, Elizabeth.
 Women in the Japanese World / by Elizabeth Van Houten.
   p. cm. — (Women's issues, global trends)
 Includes bibliographical references (p.   ).
 ISBN 1-59084-859-4
 1. Women—Japan.  I. Title. II. Series.
 HQ1762.V36 2004
 305.4'0952—dc22
                                2004003660

Interior design by Michelle Bouch and MK Bassett-Harvey.
Illustrations by Michelle Bouch.
Produced by Harding House Publishing Service, Inc.
Cover design by Benjamin Stewart.
Printed in India.

# CONTENTS

Introduction • 7

ONE
Women in History • 11

TWO
Women Today • 25

THREE
Women in the Home • 37

FOUR
Women Outside the Home • 49

FIVE
Women and Tradition • 59

SIX
Notable Women • 73

SEVEN
Issues and Challenges • 91

Glossary • 102
Glossary of Japanese Words • 105
Further Reading • 108
For More Information • 109
Index • 110
Picture Credits and Bographies • 112

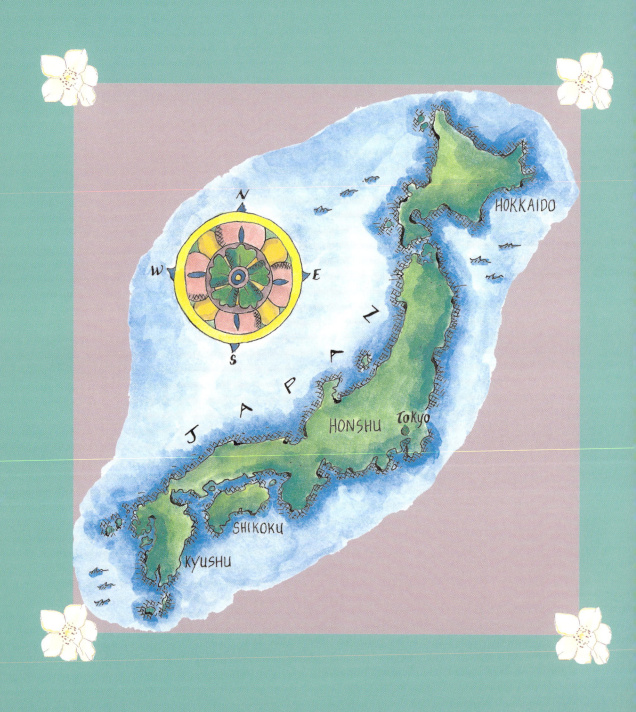

# INTRODUCTION

*by Mary Jo Dudley*

The last thirty years have been a time of great progress for women around the world. In some countries, especially where women have more access to education and work opportunities, the relationships between women and men have changed radically. The boundaries between men's roles and women's roles have been crossed, and women are enjoying many experiences that were denied them in past centuries.

But there is still much to be done. On the global stage, women are increasingly the ones who suffer most from poverty. At the same time that they produce 75 to 90 percent of the world's food crops, they are also responsible for taking care of their households. According to the United Nations, in no country in the world do men come anywhere near to spending as much time on housework as women do. This means that women's job opportunities are often extremely limited, contributing to the "feminization of poverty."

In fact, two out of every three poor adults are women. According to the Decade of Women, "Women do two-thirds of the world's work, receive 10 percent of the world's income, and own one percent of the means of production." Women often have no choice but to take jobs that lack long-term security or

adequate pay; many women work in dangerous working conditions or in unprotected home-based industries. This series clearly illustrates how historic events and contemporary trends (such as war, conflicts, and migration) have also contributed to women's loss of property and diminished access to resources.

A recent report from Human Rights Watch indicates that many countries continue to deny women basic legal protections. Amnesty International points out, "Governments are not living up to their promises under the Women's Convention to protect women from discrimination and violence such as rape and female genital mutilation." Many nations—including the United States—have not ratified the United Nations' Women's Treaty.

During times of armed conflict, especially under policies of ethnic cleansing, women are particularly at risk. Murder, torture, systematic rape, forced pregnancy and forced abortions are all too common human rights violations endured by women around the world. This series presents the experience of women in Vietnam, Cambodia, the Middle East, and other war torn regions.

In the political arena, equality between men and women has still not been achieved. Around the world, women are underrepresented in their local and national governments; on average, women represent only 10 percent of all legislators worldwide. This series provides excellent examples of key female leaders who have promoted women's rights and occupied unique leadership positions, despite historical contexts that would normally have shut them out from political and social prominence.

The Fourth World Conference on Women called upon the international community to take action in the following areas of concern:

- the persistent and increasing burden of poverty on women
- inequalities and inadequacies in access to education and training
- inequalities and inadequacies in access to health care and related services
- violence against women

- the effects of armed or other kinds of conflict on women
- inequality in economic structures and policies, in all forms of productive processes, and in access to resources
- insufficient mechanisms at all levels to promote the advancement of women
- lack of protection of women's human rights
- stereotyping of women and inequality in women's participation in all community systems, especially the media
- gender inequalities in the management of natural resources and the safeguarding of the environment
- persistent discrimination against and violation of the rights of the girl child

The Conference's mission statement includes these sentences: "Equality between women and men is a matter of human rights and a condition for social justice and is also a necessary and fundamental prerequisite for equality, development and peace. . . equality between women and men is a condition . . . for society to meet the challenges of the twenty-first century." This series provides examples of how women have risen above adversity, despite their disadvantaged social, economic, and political positions.

Each book in WOMEN'S ISSUES: GLOBAL TRENDS takes a look at women's lives in a different key region or culture, revealing the history, contributions, triumphs, and challenges of women around the world. Women play key roles in shaping families, spirituality, and societies. By interweaving historic backdrops with the modern-day evolving role of women in the home and in society at large, this series presents the important part women play as cultural communicators. Protection of women's rights is an integral part of universal human rights, peace, and economic security. As a result, readers who gain understanding of women's lives around the world will have deeper insight into the current condition of global interactions.

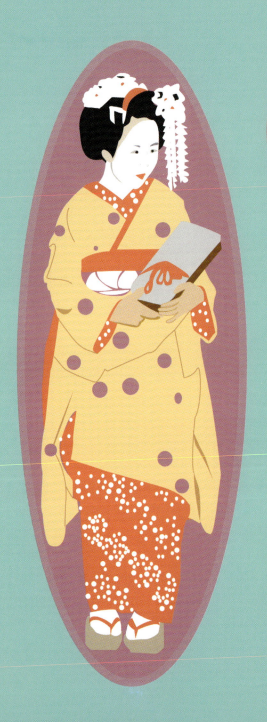

"IN THE BEGINNING, WOMAN WAS THE SUN."
—HIRATSUKA RAICHO, FEMINIST ACTIVIST, 1911

# WOMEN IN HISTORY

According to the earliest legends of Japan, the beautiful and powerful goddess of the sun, Amaterasu, gave the people of Japan valuable gifts: grain, silkmaking, and looms for weaving. Amaterasu sent her grandson to earth, and her descendant Jimmu became the first *tenno* (emperor) of Japan. In times of trouble, leaders prayed for Amaterasu's assistance at the shrine at Ise. Today, the generous red sun is shown on the Japanese flag.

A Chinese document from the late third century B.C.E. about the people of Wa (Japan) reported that women and men had equal rights and worked in the fields together. Historians guess that ancient Japan was peopled by about a hundred clans, spread across the large volcanic islands of Hokkaido, Honshu, Shikoku, and Kyushu. These groups survived by fishing and **subsistence farming** of fruits, vegetables, beans, and rice. They worshiped the spirits of the earth, a religion that came to be called *Shinto*.

By the sixth century B.C.E., cultural influences from China, especially the Buddhist religion that had traveled to China from India, changed this organization

## HER MAJESTY, THE EMPEROR

There are legends about ancient, magical warrior-queens, such as Himiko and Jingu Kogu. According to the history, there were also eight female tenno between the sixth and eighth centuries. They were usually the widows of emperors or ruled on behalf of their young sons but often were great rulers in their own right. Due to the influence of Confucianist ideas about women's inferiority to men, centuries passed before there were two more women emperors, Meisho (reigned 1630–43) and Go-Sakuramachi (reigned 1762–1771). By then, power over the kingdom was in the hands of wealthy nobles and military leaders. The Meiji Constitution of 1889 forbade women from ever becoming emperor again.

Although they did not rule, emperors' wives and consorts were considered nearly divine, and led the court in fashion and culture. Haru Ko, wife of the Meiji Emperor in the late 1800s, set an example for the whole kingdom by coming out of seclusion to set up charities and hospitals for women.

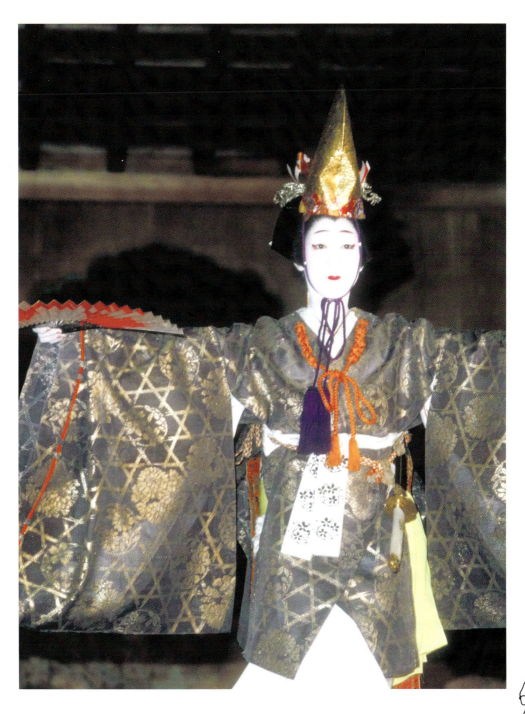

WOMEN IN HISTORY 13

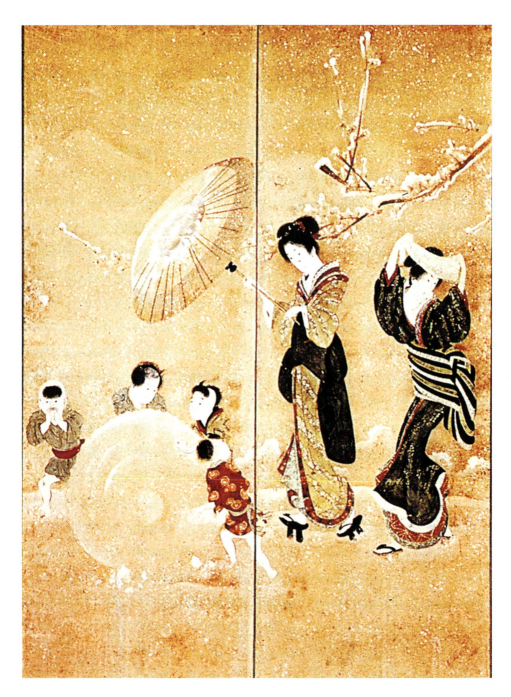

WOMEN IN THE JAPANESE WORLD

profoundly. Japan's political leaders set up a government based on the ideas of Confucius, an ancient Chinese philosopher. According to his teachings, every person is born into a status that cannot be changed. Everyone beneath the emperor owed loyalty and respect to the person the next step up on the ladder. The emperor and his family were regarded as holy, but most of the real power was in the hands of wealthy nobles and government officials.

The aristocrats and *ladies-in-waiting* at the emperor's court were very important in developing the art and culture of the nation. Women's ideas helped to establish standards of etiquette that emphasized thoughtfulness and politeness. Clothing and hair styles were elaborate, so preparing for the day took a long time. Noblewomen kept long diaries describing their lives. They also wrote poems, religious meditations, witty sayings, and stories based on their experiences at court. A lady known as Sei Shonagon wrote the most famous collection of observations, *The Pillow Book*. Her literary rival, Murasaki Shikibu, is credited with writing the world's first novel, *The Tale of Genji*, around the year 1000. (When writing Japanese names, the surname or family name is placed first and the personal name second. However, women's personal names were not recorded at this time, so names of court writers were adapted from their family's names).

In 1192, after a period of rebellions against the emperor, Minamoto no Yoritomo declared himself *shogun* (military ruler) and set up headquarters in Kamakura, near modern-day Tokyo. From then on, the shoguns and their families were in control. The emperor's small family and court still continued to live in Kyoto. Under the shogun's supervision were a few dozen powerful landowners called *daimyo*, who owned large farming estates and controlled the peasants who worked there. They had warriors called *samurai* ("those who serve") to defend them. The samurai swore to protect the daimyo. If a samurai felt that he had failed his leader, he was expected to kill himself, or commit *seppuku*.

Women could not be warriors or government officials. Girls of the upper classes were forced into arranged marriages, sometimes at a very young age, and used as political hostages by their warring families. A few women became Buddhist or Shinto nuns, but most girls of the samurai class often left their homes around age ten to become an apprentice lady-in-waiting at a daimyo's palace. While they maintained a tranquil appearance, samurai women were trained to defend the estate if an enemy should attack while the warriors were away. In 1868, even young girls fought in the last stand of the shogun's army at Wakamatsu Fortress.

Ladies were expected to sacrifice everything, if necessary, to protect their family's honor. In a famous legend, "The Loyal *Ronin*," a wife sells herself as a slave so that her husband can use the money in a noble cause. Sometimes women carried out revenge against those who had wronged their family. Women also committed seppuku in matters of honor.

Beginning with Portuguese explorers in the early 1540s, European merchants and missionaries began to visit Japan. At first, the Japanese were intrigued by the Europeans. However, many were alarmed by the spread of Christianity and saw the foreigners as a threat. Beginning with Tokugawa Ieyasu in 1600, the shoguns maintained a policy of isolation for over two centuries. This new regime also held tighter control over the daimyo by requiring their wives and children to remain in the capital, Edo, when the daimyo were away. The daimyo's city houses brought about a new class of merchants and artisans to support them. Over time, Edo, Osaka, and Kyoto became cities with hundreds of thousands of people.

In 1854, Commodore Matthew Perry of the United States Navy forced the shogun to allow foreign ships free access to Japan's ports. In order to combat the influence of the westerners, the new leaders decided they must catch up to them with modern technology and ideas. A new government based once again around the emperor was established in 1868. The government sent students,

WOMEN IN HISTORY

## LIFE OUTSIDE THE PALACE WALLS

Over 80 percent of the Japanese population were peasant farmers until the nineteenth century. Women helped their families work in the rice fields or, if they lived in a fishing community, took care of the household while their husband was away at sea. Women were also almost completely in charge of making silk and **tofu**, a soybean curd that is still an essential part of the Japanese diet. High taxes kept most farmers poor. Desperate families were compelled to sell their daughters as prostitutes or laborers. Sometimes, midwives killed babies when they were born because their parents could not afford to feed them.

including girls, to America and Europe to learn about western ways. These five decades of change became known as the "Meiji Restoration," after the name of the emperor.

The Meiji Restoration brought about a sense of possibility and experimentation, especially in cities. A new parliamentary government was established, and the *traditional* privileges of the daimyo and samurai were stripped away.

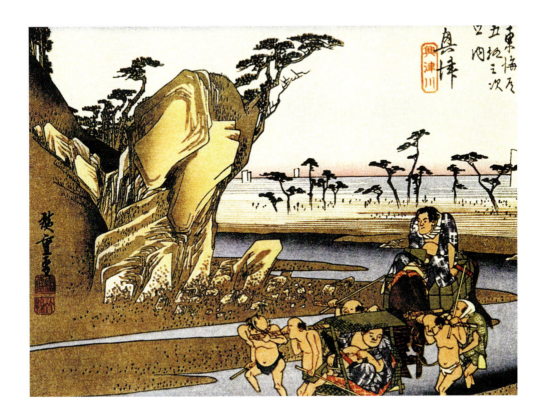

New inventions like railroads and the telegraph unified the country. In the 1920s, modern girls, or *mogu*, exchanged their kimonos for daring American skirts that went above the knee. They bobbed their hair like American *flappers* and wore high heeled shoes instead of traditional sandals. They went to work in the cities and enjoyed American movies and music.

The government and media were highly suspicious of these "new women." The ideal of *ryosai kenbo*, "good wives and wise mothers," came to prevail in official rulings. Laws passed in 1890 made it illegal for women to participate in political activities. Since women were commonly paid only about half as much

## JAPAN TODAY

Area: 145,882 square miles (234,774 kilometers)

Major cities: Tokyo, Yokohama, Osaka, Nagoya

Population: 127 million (51 percent female)

Population growth rate: 0.11 percent

Life expectancy: male 77, female 84

Average household size: 2.67 persons

Literacy: 99 percent

Ethnicity: 99 percent Japanese, 1 percent other, (Korean, Chinese, indigenous Ainu)

Major industries: electronics, motor vehicles, steel, textiles, financial services

Government: parliamentary democracy

Leaders: Emperor Akihito (ceremonial); Prime Minister Junichuro Koizumi

Legislature: Two-house Diet. House of Representatives (480 members) and House of Councilors (247 members).

(Source: 2003 CIA World Factbook)

as men, even women with full-time jobs usually could not afford to live on their own, nor was it considered respectable to do so.

While there seemed to be some advances on the horizon for women's causes, the *feminists'* hopes were overpowered by other events. A serious earthquake in 1923 severely hurt the economy. An epidemic of tuberculosis, a lung disease, claimed many lives. In 1931, Japan took over the Chinese state of Manchuria, and by 1937 the two nations were formally at war. On December 7, 1941, Japanese planes attacked an American naval base at Pearl Harbor, Hawaii, and for the next three years Japan and the United States, along with other Allied nations, were at war by air and sea.

During the war, some women went to work in factories whose male workers had joined the military. Many women from Japan-occupied Korea were forced to act as prostitutes ("comfort women") for Japanese soldiers. Life for ordinary women was difficult, as the war drained resources and supplies for use by the military. Food and necessities were *rationed*. Women worked with their neighbors to survive these terrible conditions, but things just went from bad to worse.

Japan's military government refused to surrender even when, by late 1944, American planes were bombing factories and cities in southern Japan. Incendiary (fire) bombing continued for many months, killing hundreds of thousands of people. On August 6 and 9, 1945, American planes dropped nuclear bombs on the cities of Hiroshima and Nagasaki, killing thousands of civilian men, women, and children. Thousands more would eventually die from leukemia, a disease caused by nuclear fallout. By the end of the war a few days later, many of Japan's cities were in ruins, and thousands of women and children had fled to the country.

Until 1952, Japan was occupied by American forces who helped to rebuild from the destruction of the war and restart Japan's economy. They also oversaw

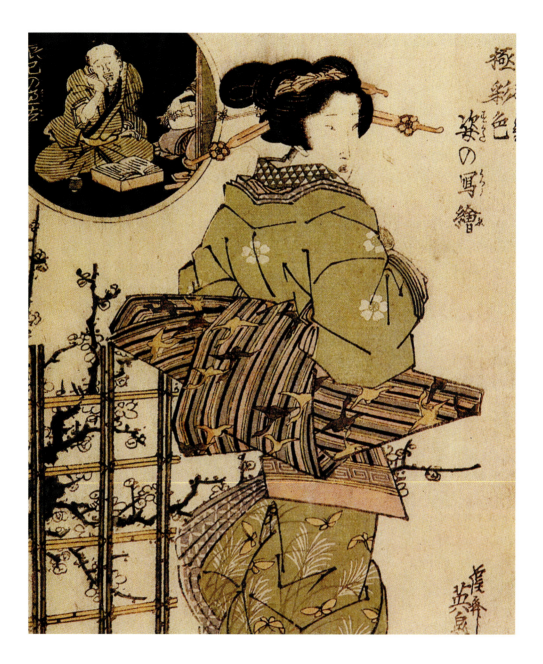

the writing of a Constitution that reduced the power of the emperor and the military. The new Constitution also greatly reformed earlier restrictions on women enacted under the Meiji regime. The Constitution states that "All of the people are equal under the law and there shall be no discrimination . . . because of race, sex, creed, social status or family origin."

"OUR PRIMARY GOAL IS NOT TO BE LIKE MEN, BUT TO VALUE WHAT IT MEANS TO BE A WOMAN."
—UENO CHIZUKO, SOCIOLOGIST

# 2

## WOMEN TODAY

A few autumn leaves blew in the apartment door as Keiko returned home to Yokohama after a vacation. She had graduated from a university the month before, and celebrated by visiting Hawaii with a friend from school.

"*Okaasan*! *Fumiko*! I'm home!"

"Welcome home, Keiko!" called her younger sister from the room they shared.

"Turn off the TV and do your homework, Fumiko!" Keiko called back.

Keiko's mother was busy preparing a special meal on the low table in the family's traditional living room. Keiko's father, as usual, would be working overtime at his office and wouldn't be home for several hours.

"I'm so glad you had a nice vacation, Keiko-*chan*." Keiko's mother beamed. "And I'm so proud you did well at university. Are you going to apply soon to the computer company your father works for? I know it might not be very exciting to work in an office, but it would only be for a few years, until you are married."

WOMEN IN THE JAPANESE WORLD

"Sadako and I talked a lot about our future when we were away," Keiko said. "She wants to get an apartment in Tokyo and try to work at a newspaper. That sounds like a good idea to me. I loved studying politics in college, and I would like to have a job that allows me some freedom."

"*Okaasan*, do you ever wish that you had kept your job at the hospital when you were married?" asked Fumiko. "I know that you wanted to study medicine."

Her mother paused for a moment. "I am only glad that I have raised such smart daughters, who have many options for their future." She smiled.

❁ ❁ ❁

Despite a sudden slump in the economy in the mid-1990s, since the end of World War II Japan has become one of the most technologically sophisticated nations. Today, women in Japan enjoy one of the highest standards of living in the world. In 1946, women voted for the first time, electing thirty-nine women members to the House of Representatives. Women's life expectancy is eighty-four years and keeps rising. Japan also has one of the highest rankings for women's enrollment in higher education. According to government statistics, the number of women in universities has more than doubled since 1985.

These positive steps, however, have taken several decades to develop. Two major ideas have had an enormous influence on postwar Japanese society, both with roots that reach far back into the country's history and the teachings of Confucianism. The first is the concept of putting the group's needs over your own. Like the ties of loyalty between different classes in the past, an individual still feels a great sense of responsibility to the family, the workplace, and the nation. Individuality is discouraged; a popular saying of Confucius is "the nail that sticks up gets hammered down." Nowadays, it is assumed that a man's first obligation is to his job. Similar values are encouraged for children, to their schools,

and women, to their homes and family. Suicide over issues of honor is not unknown even today.

The second ideal is the exaltation of the nuclear family, the *ie*. While ancient attitudes saw men and women as equal, the influence of Chinese ideas pictured women as subjects to be controlled by the family group, rather than as individuals with their own dreams and rights. Most marriages were considered an arrangement for continuing the *ie*, with romantic love definitely taking second place to financial stability. Every aspect of women's behavior was supposed to contribute to the family's honor. The Meiji *ryosai kenbo* ideal still exists in the popular imagination if not in law.

In just a few years after the destruction of World War II, Japan became one of the world's leading producers of electronics. Huge super-cities with skyscraper offices and tall apartment buildings sprang up around Tokyo and Osaka. In less than a century, Japan had changed from an agricultural economy to one based in manufacturing and **service industries**. New arrangements for working and living naturally had an effect on women's roles.

Under the influence of the American *occupation*, many reforms that Japanese feminists had been urging for decades were finally made law. Women enjoyed much greater freedom of choice in education and employment in the postwar years. Many women attended junior colleges or universities (most men's universities opened their doors to women soon after the war). No matter their level of education, however, women were strongly encouraged by their parents to be married by age twenty-five. If a woman happened to take a job, it was not supposed to be a lifelong career, but a way "to learn about the world." The stereotype of men became the business-suit-wearing "salary-man" (*sarariman*), who worked long hours and commuted by train every day, and the majority of married women were stay-at-home housewives.

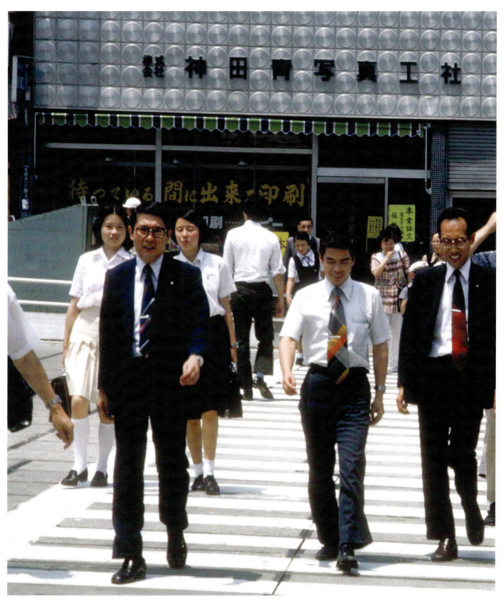

Although today's Japanese women have entered the business world, most Japanese businesspeople are still men.

WOMEN TODAY 29

While women considered themselves very lucky if they were truly "in love" with their husband, most husbands and wives worked out an arrangement of side-by-side living. Wives accepted their responsibility as homemakers and raisers of children and were not usually interested in their husbands' work. It was considered attractive for wives to appear meek. If they were walking together outside, wives walked a step or two behind their husbands. These may seem like difficult or unfair circumstances, but women were raised to respect and fulfill the roles expected of them. Legal and social trends have gained women more equality in recent years.

In the postwar era, Japanese women also have had control over their reproduction. There is no religious *taboo* in Japanese culture against family planning, and concerns about finances and space prompt most couples to have only one or two children. The 1948 *Eugenics* Protection Law made abortion safe and legal. Most women have access to abortion, and door-to-door saleswomen sell birth control products.

While the pattern of women as housewives and men as hardworking salary-earners persists as the social norm, the last fifty years has found women entering the workforce in steadily increasing numbers. Some are part-time workers, housewives who work at shops, offices, or factories to earn extra money for family needs. Gaining equal treatment for women workers has been a constant struggle. Women are statistically paid much less than men. Since many women were pressured to quit their jobs at a young age, as Keiko's mother did, it was difficult for them to advance to better-paid positions.

Young women who pursue advanced studies at a university are not satisfied to immediately "settle down" to a life of housework and childrearing. Today, more women workers are married than not. The number of women in managerial positions has more than doubled in the last twenty years. Especially in the last two decades, women have also been pioneering traditional "men's" jobs in

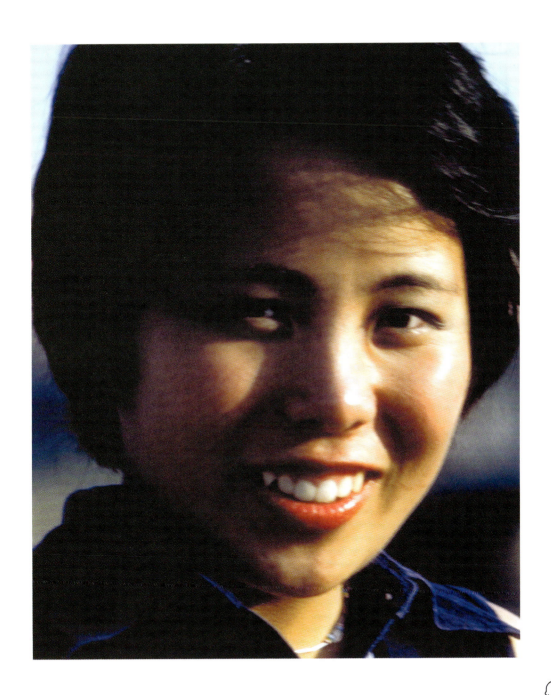

WOMEN TODAY

## IN THE COUNTRY

While Japan has had an agricultural economy for most of its history, today over 80 percent of all Japanese live in cities. The adoption of western practices and the labor-saving conveniences of modern technology have taken much longer to reach the country. Many traditions that restrict women's independence continue to be common in rural areas. Since life in the cities seems more attractive, many women have left their childhood homes to work away from their families. Work on farms is hard, and women share tasks with their husbands. It has become so difficult for bachelor farmers to find women to marry that many "import" brides from other Asian nations like the Philippines and Korea.

WOMEN TODAY

WOMEN IN THE JAPANESE WORLD

every field imaginable. Older generations and the media wonder what effect women's newfound roles will have on the traditional *ie*. Conflict between new and old ways of thinking about what a woman can do is still very much a part of women's lives in Japan.

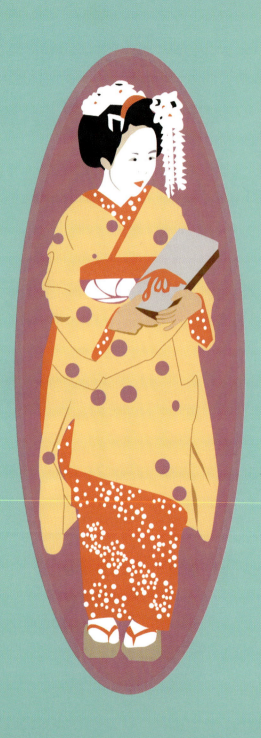

"BE ALWAYS GENTLE, SUBMISSIVE, AND COURTEOUS AS HAVE ALWAYS BEEN OUR WOMEN IN THE PAST."
—TSUDA UMEKO, EDUCATOR, 1900

## WOMEN IN THE HOME

Keiko and Fumiko walked through the neighborhood park after dinner. "I missed home when I was away," said Keiko. "It's so comfortable, and *Okaasan* is such a good cook!"

"*Okaasan* has been teaching me how to cook, too. Soon we'll have our own families to care for," Fumiko said, smiling as a baby went by in her mother's arms. "Do you want to marry soon, Keiko?"

Keiko shrugged. "I've met some nice guys, but all they think about is work."

"I don't like the boys at my school. I want to have an old-fashioned marriage, an arranged one," said Fumiko mischievously.

Keiko rolled her eyes. "Grandmother had ten matches before she met grandfather! I know you wouldn't be able to be so patient!"

Among the aristocracy, marriages were arranged by families for social or economic advantage, and it was difficult for young people to escape this system. For many years, it was common for girls to marry in their early teens. Women often married men much older than they were or whom they hardly knew at

all. Japanese literature is filled with stories of doomed lovers committing suicide together.

While peasants and artisans had generally a bit more freedom, traditional marriage arrangements left a wife with few rights. The only way a woman could get a divorce was by running away from home and living in a special shelter for three years, while a man could divorce his wife by writing her a letter. Even in the Meiji period, women were under constant threat of divorce if they displeased their husband or his family. Daughters-in-law were often expected to work for the family business for no pay. Traditionally, the wife of an eldest son was responsible for taking care of her husband's parents as well as her own. A mother-in-law (*mama-san*) felt free to criticize her daughter-in-law, but expected to be treated at all times with respect.

Reforms to rules about marriage and divorce during the American occupation made wives and husbands equal before the law, but the importance of maintaining traditional family hierarchy remains supreme. While young people idealize a romantic partnership with a spouse they love, in the postwar era most couples split their responsibilities strictly along the lines of work and home.

More than half of all marriages were arranged until the 1960s. For young women, there was great social pressure not to become a "Christmas cake" (leftovers)—what an English-speaker might unkindly call an "old maid." In the Japanese view, it was expected that the husband and wife would come to respect and admire each other over the years of their marriage, rather than be passionately "in love" *before* deciding to spend their lives together.

The typical husband's overtime work, six-day workweek, long commute, and business trips means that he usually spends little time in the home, and is very tired when he does return. After work, it has become customary for men to go to a bar with their coworkers to relax and discuss business. At home, they expect their wives to serve them meals and snacks, but they usually do not regard them as a close friend or companion. The worlds of husband and wife are so different that many older couples find they don't talk much at all.

WOMEN IN THE JAPANESE WORLD

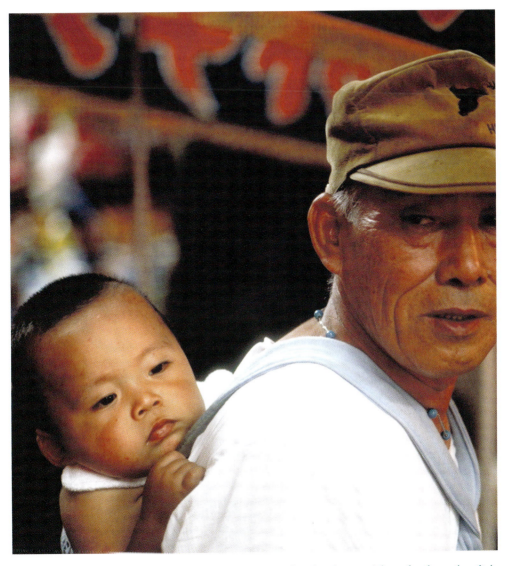

Men in Japan today take more responsibility for childcare—but their long workdays often leave them little time for moments like these.

WOMEN IN THE HOME

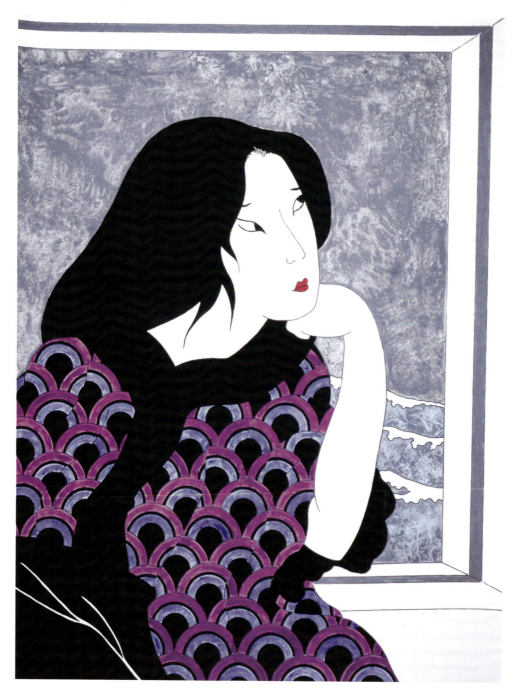

WOMEN IN THE JAPANESE WORLD

In these circumstances, married people might discreetly seek romantic love outside of their marriage, but divorce is rare compared to other developed nations, partly because of the traditional difficulty for divorced women to marry again. Men, however, are considered more "manly" and successful if they have mistresses outside of marriage. Many married women and men have said in polls that they do not regard monogamy (having only one sexual partner) as very important for a marriage's success.

## MATCHMAKER, MATCHMAKER

Young men and, in some cases now, young women are pushed so much by their parents to do well in school and participate in after-school activities that they have little time to socialize, so many people still meet their spouses through arranged marriages.

The matchmaking process is similar to applying for a job. Families exchange young people's resumes and photographs as well as records of their parents' and relatives' employment, education, and finances. An older married woman may serve as matchmaker for her friends' children. She may meet them at a restaurant, introduce them, and leave after they begin to have a conversation.

After the meeting, the young man and woman will call her and tell her how the date went. Each will send the matchmaker a thank-you gift. If they like each other, they will continue to date. Internet matchmaking is becoming popular as well.

WOMEN IN THE HOME

Even the American-looking *mogu* of the 1920s regarded traditional motherhood as the appropriate role for a woman. The prevailing view was that a woman was not really a woman unless she married and had children. To be a wife was referred to as *eikyu shushoku*, "eternal employment." Women's housework and childcare was seen as a "profession" just as important as men's paid work outside the home. Most men and women thought that this view respected women as guardians of traditional values rather than demeaned them to drudgework.

Wives are encouraged to spend all their efforts keeping their homes tidy and their family comfortable. The ideal wife cooks, cleans, airs out the futons the family sleeps on, washes the laundry, and takes care of young children and older relatives. Without electric appliances, even a normal family meal requires a lot of time to cook, serve, and clean up after. Many women shop for fresh food every day, often riding their bicycles to the market. Rice, soup, vegetables, and fish are the basis of the traditional Japanese diet, although foods from other countries are popular nowadays. Prepared meals are also available.

With the availability of time-saving appliances in the 1960s and 70s, like rice cookers and vacuum cleaners, housewives had more time for their own interests. Radio and television brought them entertainment and connected them to the outside world. A common saying calls a television, a washing machine, and a refrigerator the "three sacred treasures" of a home, jokingly comparing them to the three holy emblems of the emperor. With their free time, women took up hobbies or part-time jobs. However, if it seemed that they were not able to keep up the former standards of care expected of a good wife, they would give up these activities willingly.

According to an official survey in 2001, working husbands spend an average of twenty minutes a day on child care and housework, while their wives spend nearly five hours cooking, cleaning, and taking care of children. One reason why generations of Japanese women have maintained the "housewife" role in large

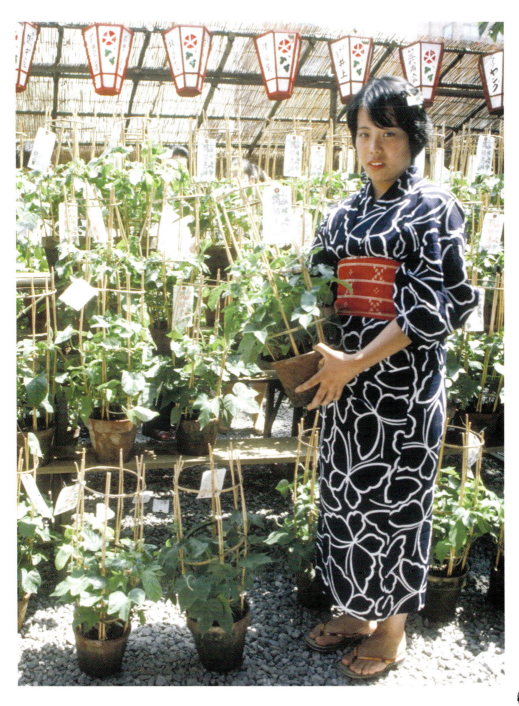

WOMEN IN THE HOME

## A JAPANESE HOME

The home is traditionally viewed as a retreat from the stresses and dangers of the outside world. Under the watchful care of a wife, hardworking husbands can relax and children can escape the pressure of school. Houses are kept spotlessly clean, and it is customary to take off one's shoes before entering. There are usually traditional decorations, such as paintings and flower arrangements. By the twenty-first century, most apartments in Japanese cities have the same appliances, televisions, stereos, and video games that would be found in an American home, but because there is so little space available, there is not much furniture.

The floor of the family's central room is often covered with traditional woven mats called **tatami**. There may be sliding doors or traditional screens rather than hinged doors. Some families eat in the traditional style, sitting on pillows around a low table. Most homes have a small shrine to their deceased ancestors, especially grandparents, in this room. The parents may also sleep in this room on portable futon mattresses.

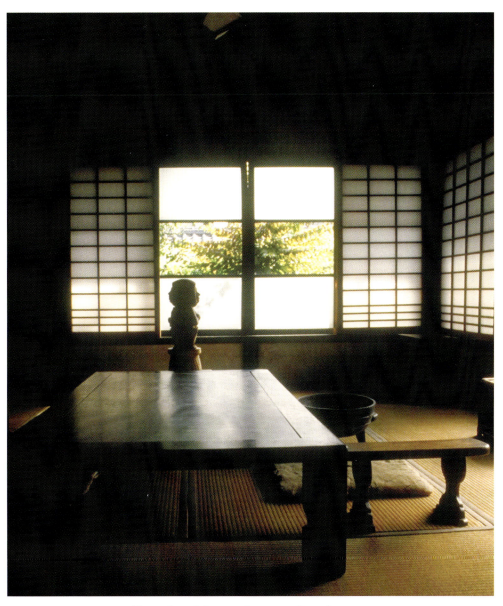

The traditional Japanese home is a place of serenity.

WOMEN IN THE HOME

Japanese tradition focuses on order and balance. Modern Japanese women work hard to achieve this sense of balanced orderliness in their families.

numbers may be their power over home finances. Until a few decades ago, it was customary for a husband to formally present his wife with his weekly earnings on payday. It was her job to pay bills, do the food shopping, and decide on purchases for the household. With the money left over she could buy things for herself and save up for family treats.

Unlike the American concept of mothers and fathers being equal parents, in Japan it is taken for granted that mothers have a much closer bond with their children because they give birth to them. Until recently, it was very rare for husbands to help their wives during pregnancy, or even accompany them during labor.

Japanese mothers have a much larger role in raising children than working fathers, who may only be a small presence in their children's lives. Many mothers are very affectionate and indulgent with their children, believing that they will be treated with similar kindness and respect when they have grown old. The concept of baby-sitting is not popular in Japan, because to pay for a stranger to watch one's children seems selfish.

Beginning with kindergarten, mothers are expected to prepare their children's lunches and ensure that they are dressed neatly. A student's performance in school reflects on his or her mother. Since a good education in "the best" schools is seen as essential to achieving a respectable career, most mothers are devoted to helping their children achieve in school. The exam process for private schools is extremely competitive, even for kindergarten. Mothers help their children study at home. They may work at a part-time job to help pay for their child to attend *juku*—expensive exam preparation class. Women who take such an interest in their children's achievement are often made fun of as "education mamas," but their demanding standards are part of their expected role as upholders of the family honor. As in the past, mothers often help to select suitable marriage partners for their children as well.

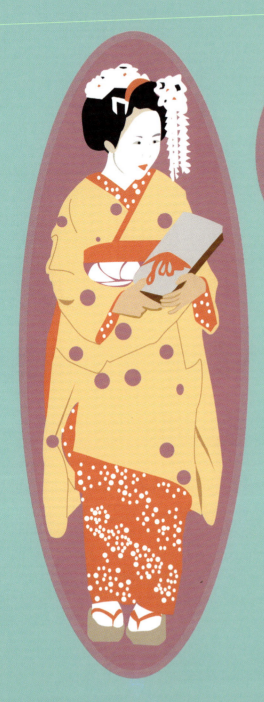

"WE CAN BELIEVE NO LONGER THAT REPRODUCING OFFSPRING IS WOMEN'S ONLY WORK, OR THAT MARRIAGE IS THE SOLE POSSIBLE WAY BY WHICH WOMEN CAN MAINTAIN THEIR LIVES, OR THAT TO BE A WIFE AND MOTHER IS ALL WOMEN'S VOCATION."
—HIRATSUKA RAICHO, 1913

## WOMEN OUTSIDE THE HOME

Fumiko took the train to meet Keiko in a coffee shop one November afternoon.

"How was school today? Did you have soccer practice?" Keiko asked.

"No, nothing so fun, just cramming for the exams at *juku*." Fumiko made a face. "How was your interview with the newspaper editor?"

"I think it went well, although he asked me a lot of questions. He asked if I was married, and how long I thought I might stay with the paper if I decide to have children. He said I could be a secretary—an *office lady* or "O.L."—or, if I was committed to working hard, I could have a position as a researcher with the national news section."

"You did so well at school, Keiko! You could become a real reporter in no time!"

"I'm not sure what I want to do," she said thoughtfully. "I would be expected to work overtime every night like Father does, and maybe I would be posted to work in another city. I would have to quit if I get married and have children.

Being an office lady might be boring after a while, but at least I would still have time for my friends and playing tennis."

Since the earliest villages in ancient Japan, women were a vital part of the agricultural economy. In the larger towns, they worked selling vegetables and other goods. A few women became professional dancers and musicians. Others ran inns and teahouses. During the *industrialization* era of the 1800s, women worked under backbreaking, poorly paid circumstances in mines and factories. In addition to working very hard all day, women were also expected to raise their children, prepare meals, and take care of their households.

Despite this evidence to the contrary, officially women were considered less physically and mentally able than men. Upper-class women were not allowed to work or receive much of an education except in suitably "female" subjects, like literature and sewing. As the country became industrialized in the Meiji period, middle-class women as well were encouraged to stay home and follow the *ryosai kenbo* ideal. Even during World War II, the government never required married women to work for the war effort.

While most women seemed content with this system, it did not work for everyone. Many women, like the eleventh-century writer Murasaki Shikibu, were secretly frustrated that their options for education and activities were so limited. Since most young women were only trained to be meek housewives, and women by law inherited little or nothing at the death of their husband, a widowed or divorced woman would have a hard time supporting herself.

The girls' schools and colleges established under the Meiji Restoration tried to solve this problem by training women to type or speak English. Opportunities for skilled women to earn a living became more varied under the "modern" Meiji spirit. In cities, young women took jobs as sales clerks, office workers, nurses, and teachers. New technology also created new jobs, such as elevator operators and bus conductors.

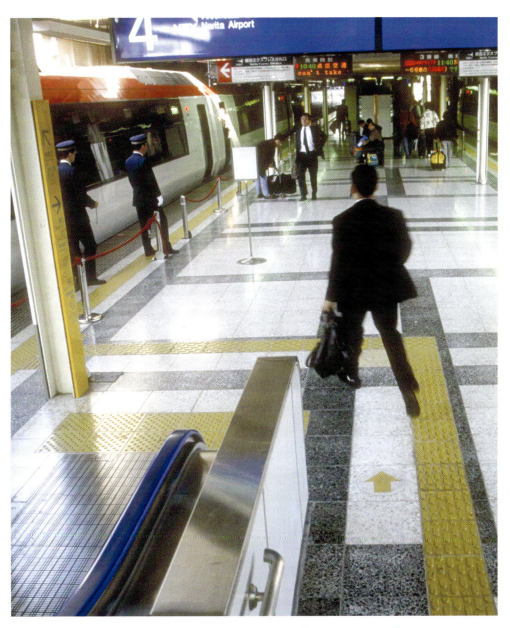

New technology has created new jobs—but more men than women occupy these positions.

WOMEN OUTSIDE THE HOME

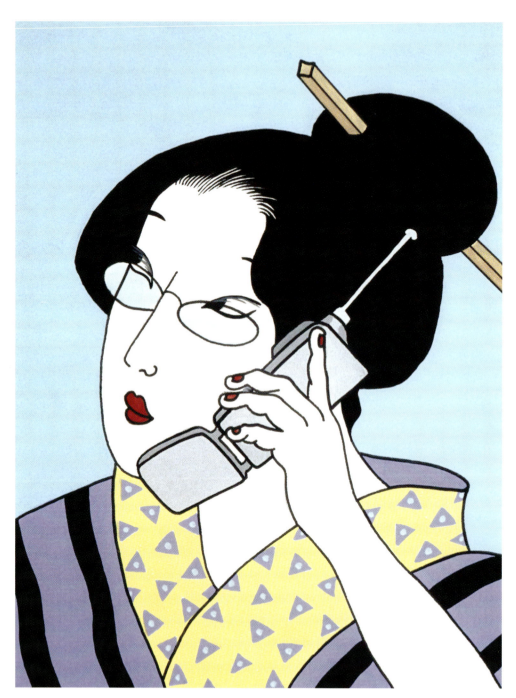

In the postwar years, women have chosen to work for a variety of reasons. After the war, many women attended "junior colleges" and, in increasing numbers, universities. Many women without paying jobs work for family businesses, or are instructors in traditional arts. Today, women are scientists, architects, news reporters, and the chairpersons of major companies. However, the traditional view that women are somehow "dishonoring" their family by not devoting themselves to *ryosai kenbo* has meant that women who want professional

## EQUAL LAWS FOR EQUAL WORK?

In 1947, the new Japanese Labor Standards Law seemed to protect women workers. The law assumed that women should have special treatment because they were not as physically strong as men and had family responsibilities. It made it illegal for women to do dangerous or physically intense work. They were forbidden to work from 10 p.m. to 5 a.m.

Over time, feminists and labor activists accused the act of being discriminatory, and in 1986 the Equal Employment Opportunity Law (EEOL) got rid of the old restrictions. (A similar legislation proposed at the same time in the United States, the Equal Rights Amendment, was never made law.) However, the law does not give any punishment to employers who do not treat women equally.

WOMEN OUTSIDE THE HOME

careers have had a difficult struggle. Many women quit their jobs when their children are born, then return to the workforce when their children are in high school.

Many of women's problems at work are due to the continued perception of work as a man's place. It is assumed that young women will only work a few years before getting married, or, at most, before they have their first child. In the 1920s, some companies tried to recruit women workers with advertisements saying that if they worked there, they would find a nice man to marry—and then quit working forever. Some employers are so puzzled by women who remain working that they require female workers to retire much earlier than men, sometimes as soon as age thirty-five! They may be passed over for promotions or transfers. Before the EEOL, companies had no obligation to hold a woman's place for her if she had to take time off to give birth.

As in Keiko's story, many women are given two options when they are offered a job. They may choose the general track and become an "office lady" (O.L.), or work alongside men on the integrated track. Men are automatically placed with the *integrated* track. About a third of all working women in Japan are so-called "office ladies," or O.L.s, who may be young to middle-aged. They serve tea, tidy offices, answer phone calls, and do secretarial work. This is not an entry-level position as it might be in the United States, but a career. Many companies offer a variety of after-work clubs and activities for their employees as well.

Many women are glad to have a job that does not require them to work hard. However, women who would like a career on the integrated track face many challenges, even today. It is considered unusual for women to work in science or business-related fields. The few women who do become managers often feel isolated and discriminated against in subtle ways. They may be silently expected to serve tea and do other tasks seen as "women's work." Due to the complexities of the Japanese language, women and men use different words when ad-

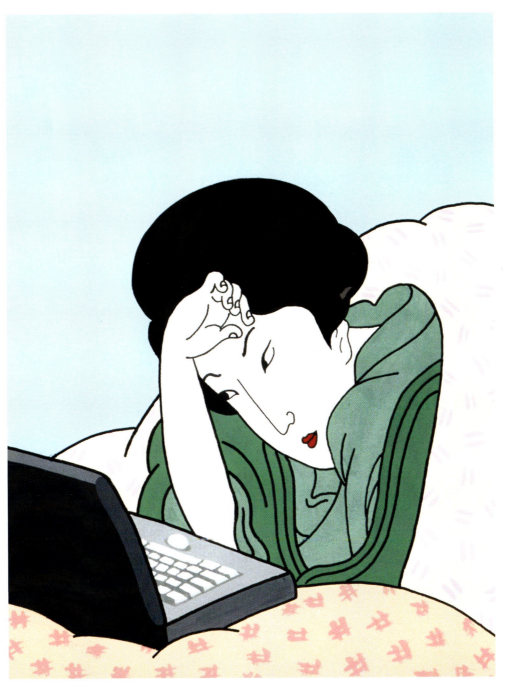

WOMEN OUTSIDE THE HOME

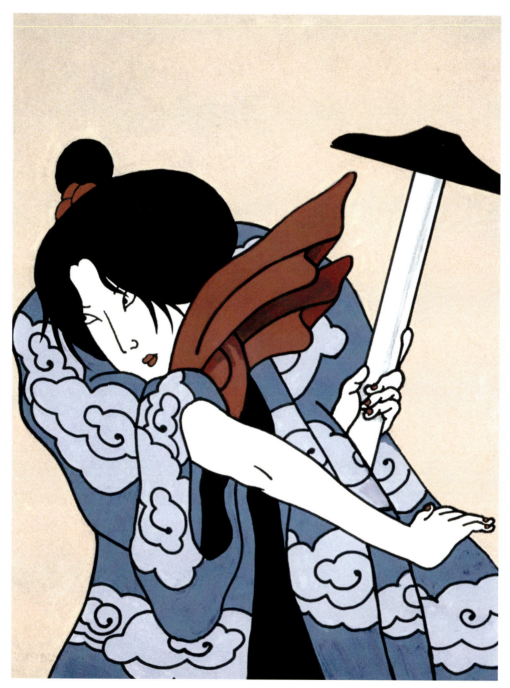

WOMEN IN THE JAPANESE WORLD

dressing one another. For a woman executive, just deciding how to speak with her colleagues is sometimes a challenge. It would not normally be considered socially proper for a woman to socialize at a bar after-hours with her male coworkers, but women managers are not part of the social group of O.L.s, either. Some women have found that they are treated more equally if they work at foreign-owned companies.

The demands of keeping up with male coworkers and caring for a family as well have also been problematic for professional women. The government did not seem to notice the difficulty of women in this situation until, in the 1980s, the birthrate decreased so much that the government became seriously worried about *depopulation.* It tried to encourage families to have more children by suggesting that businesses offer better conditions for working mothers, like paid maternity leave and day-care centers. However, not many businesses have followed the government's suggestions. While the laws intended to help them are in place, many women choose not to take family leave or have children at all because they would fall behind in work.

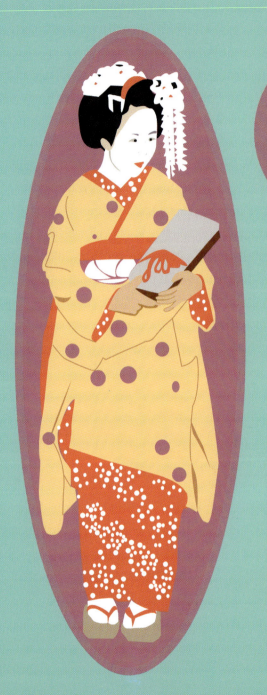

"WOMEN SHOULD PRACTICE A SPARING ECONOMY IN DISPLAYING THEIR LEARNING AND ELOQUENCE, AND SHOULD EVEN, IF CIRCUMSTANCES REQUIRE, PLEAD IGNORANCE ON SUBJECTS WITH WHICH THEY ARE FAMILIAR."
—"THE TALE OF GENJI"

# WOMEN AND TRADITION

All through her busy day at the newspaper office, Keiko had been looking forward to taking the train home to Yokohama. Finally it was time to leave, and she hurried through the streets still decorated for Christmas. Shoppers bustled to buy gifts for the New Year.

"Keiko, we're so glad you could be with us!" her mother greeted her.

"I had to work late on an article, but of course I couldn't miss coming home tonight. New Year's is time for family!" She noticed a new scroll hanging in the hallway.

"What a beautiful *shodo* painting!" she said. "Fumiko, all of your practicing has really helped."

"It was an early New Year's gift," said her mother, smiling. "She is really becoming an expert at *ikebana*, too."

Keiko took off her shoes and joined the family in the living room. Their simple Buddhist altar had a framed photograph of a smiling old woman wearing a *kimono*. In front of the small shrine, Keiko's mother had laid out a bowl of rice and a plate of sweet cakes to honor the family's ancestors.

After they prayed, the women shared memories of past family celebrations. "I always felt so special when Grandmother did *sado* with us!" said Fumiko. "Even though the tea ceremony seemed to take such a long time, I really miss her special cakes!"

The other women nodded, their minds reverently fixed on the woman who had gone before them. They knew she had faced many hardships that they never had, and yet she had been a creative and gifted woman.

While laws and customs kept women out of many aspects of life, restrictions on their behavior have sometimes been the direct cause of their involvement in the arts. Women were discouraged from learning Chinese, the official language of the Heian court, but they took the lead in writing Japanese poetry and fiction. Because women were not warriors or government workers, they had plenty of time to write and practice their musical and artistic skills.

Court women were highly competitive, and could improve their standing by performing well on the *koto*, a stringed instrument. They also competed with clothing. Fashion success required a lady to know complicated rules of color and style, which changed with the seasons. The court often organized poetry contests, and there were public readings. Women courtiers also contributed to beautiful scroll word-paintings. With the downfall of the emperor's court, women did not take as great a role in literature, but the women of the *daimyo* and *samurai* classes made exquisite handicrafts at home.

Beginning in the 1600s, artists of Kyoto and Edo made woodblock prints called *ukiyo-e*, "pictures of the floating world," depicting the beautiful *geisha* and waitresses of the entertainment districts. *Geisha* means "arts people," and these women were part of a special class of professional entertainers. While geisha were high-class prostitutes as well as performers, they studied to be "ladylike." The government treated them like professionals: they had to serve an **apprenticeship**, take an exam, register with city authorities, and pay taxes.

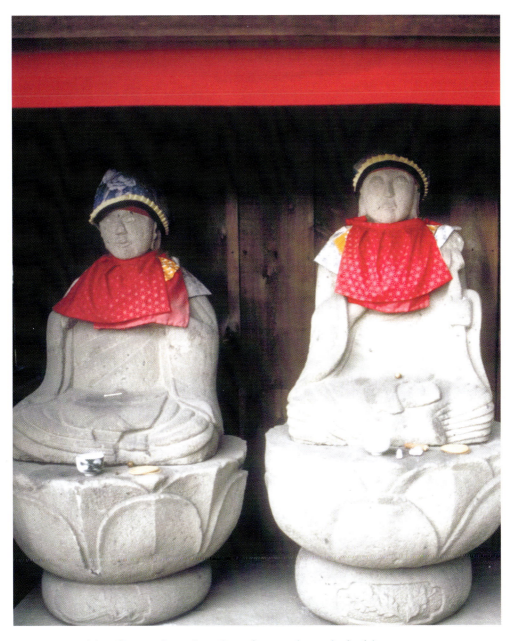

Many Japanese homes have shrines for remembering the family's ancestors.

WOMEN AND TRADITION

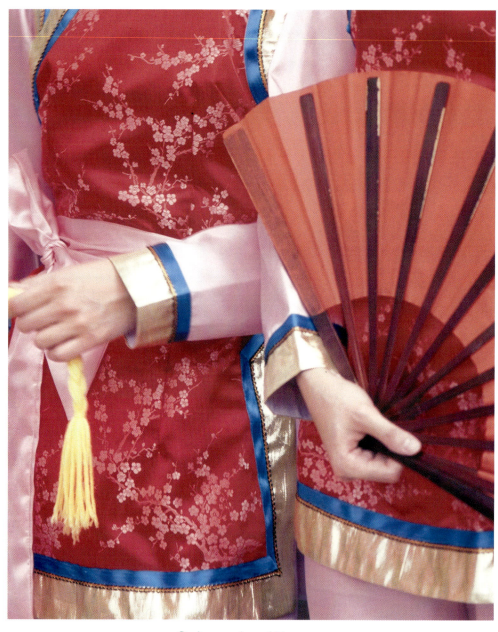

Geishas wore beautiful kimonos.

WOMEN IN THE JAPANESE WORLD

Regarded as celebrities, like movie stars are today, the geisha practiced different arts than the earlier court ladies. They played the *samishen*, a guitar-like instrument. They sang and danced for their patrons, but not in a provocative way. The geisha wore beautiful kimono and jewelry, which their male patrons would give them as payment. They arranged their long hair with fancy combs, and powdered their faces white. While apprentice geisha were sometimes sold into the profession by their poor families, being a geisha was almost a lifetime career. Women well into middle age were regarded as masters of their skills. There are few real geisha left now, and many of them are wealthy women in their later years.

In the modern era, most men work in an office environment that follows a Western model. Again, it is up to their wives to maintain the home along traditional Japanese lines. Mothers and grandmothers try to pass on traditions to the younger generation. Homemakers often use their free time to study traditional art forms at community schools and practice these skills at home. Many housewives are accomplished at playing the *koto* and samishen, *origami* (paper folding), *ikebana* (flower arranging), or *shodo* (calligraphy). The discipline and symbolism involved in these arts encourage "womanly" virtues of patience and attention to detail.

Formal flower arranging, called *ikebana*, began as a Buddhist art form in the fifteenth century. Very different from a Western-style bouquet, an ikebana arrangement may have only one or two flowers. Leaves, blossoms, and stems are carefully chosen and placed to convey symbolic meanings. Thousands of schools of ikebana exist in Japan.

At first, calligraphy was the only style of writing, introduced with Chinese written language in the sixth century. Today, ordinary writing is done with computers or ballpoint pens; writing with a brush dipped in ink is a difficult art form, like a combination of painting and handwriting. The artist must have

good posture and work gracefully. Poems and special messages are written in *shodo*. Children study *shodo* in school and sometimes as an after-school activity.

While tea masters excluded women from participating in the ceremony for centuries, *sado* is now popular with women. The ritual has its origins in *Zen*, a

## THE KIMONO

The kimono robe and **obi** sash were standard men's and women's attire for hundreds of years. Men stopped wearing them in favor of western-style trousers and shirts in the nineteenth century, and women adopted skirts and dresses in the prewar decades as well, although some older women may still wear traditional garb. Kimonos are made of expensive silk and have symbolic colors, designs, and decorations.

Today, kimonos are worn by girls and women on special occasions such as **shichi-go-san** and weddings. Young boys might also wear kimonos during festivals or when visiting a shrine. Women also wear less fancy kimonos when participating in the tea ceremony or cultural classes. Putting them on is a ritual in itself, with complicated rules for the order of garments and tying the wide obi. There are even kimono schools for learning the proper way to dress.

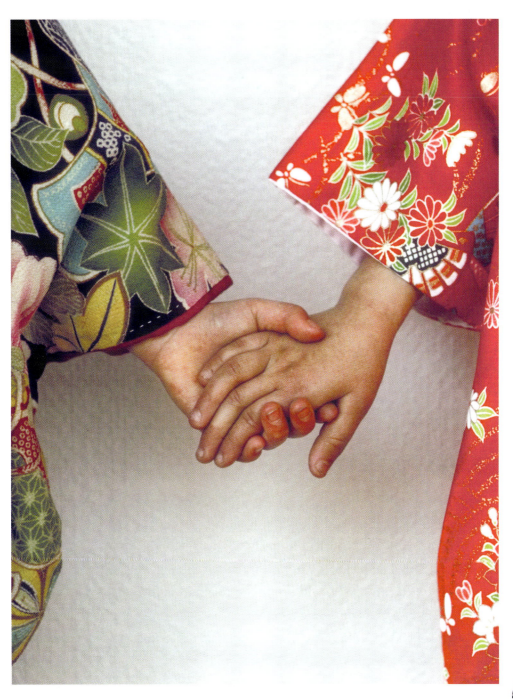

WOMEN AND TRADITION

form of Buddhism that emphasizes self-improvement through *meditation*. Every movement of preparing, serving, and drinking the bitter green tea is part of a precise plan. Special cakes are also eaten. Classes in community centers or with private teachers are popular. Families may conduct a tea ceremony dressed in *kimonos* on special occasions.

Historically, women have taken a leading role in religion. The early Shinto religion had female goddesses and women *shamans*, but Confucian and Buddhist thought usually depicted women as inferior to men. However, there were always at least a few Shinto priestesses (*miko*) and Buddhist nuns, who were organized in a convent system scattered around the country. Some women became wandering nuns called *bikuni*, who were like religious storytellers. There continue to be a few *miko* at the national *shrines* today. Some shrines, such as the one in Okinawa, are only attended by women. Women have started several new religions and *sects*.

Many homes have a small shrine in the family room depicting deceased relatives. On the anniversary of their deaths, family members may pray for them and present their shrines with gifts. Women visit Buddhist shrines to pray to the deities Jizo and Kannon to help their sick children or the souls of children who have died. They may leave small items of their baby's clothing or small stones near the gods' statues. In recent years, some Buddhist shrines have begun charging for statues (*mizugo*) and services specifically for aborted fetuses.

Holidays and festivals display layers of influence from traditional, Chinese, and American sources. Most Shinto shrines have at least one festival a year for the local god. Neighbors gather and celebrate with singing, dancing, games, or special customs. The festivals can be very noisy and exciting, with *taiko* drumming and a party atmosphere. In cities, the celebrations are very large, with parades and games. At the Sanja Festival celebrated in Tokyo in May, *geisha* process in a parade. Other festivals may feature women singing special songs or dancing in symbolic costumes.

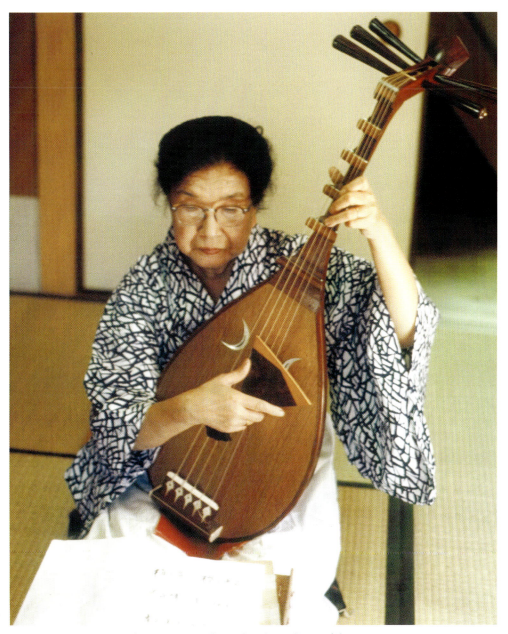

Japanese women keep alive the traditions of the past.

WOMEN AND TRADITION

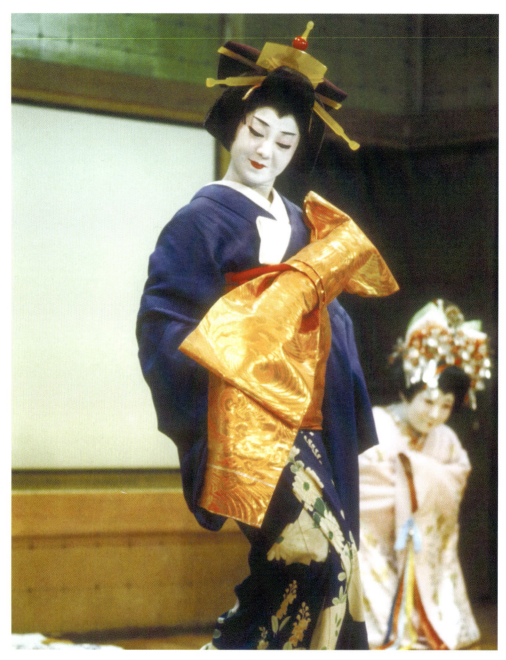

Japanese women's traditional attire was often elaborate.

## JAPANESE WEDDINGS: SOMETHING EAST, SOMETHING WEST

In recent years, there is tremendous pressure through the media and advertising to have elaborate, expensive weddings. Hotels and restaurants have Shinto shrines in special wedding rooms. Christian rituals are becoming popular, exposed to Japanese through movies. Many brides and grooms exchange rings as part of a Japanese ceremony. Some couples, however, opt for a full church service, whether or not they are Christian themselves. Brides wear several kimonos and dresses during the ceremony and reception. Often, a bride wears a traditional wedding kimono for the ceremony, performed by a priest at a shrine, then changes into a white gown. Guests may attend in a mixture of Japanese and Western formal clothes. The reception may serve Japanese food with a giant tiered American-style wedding cake.

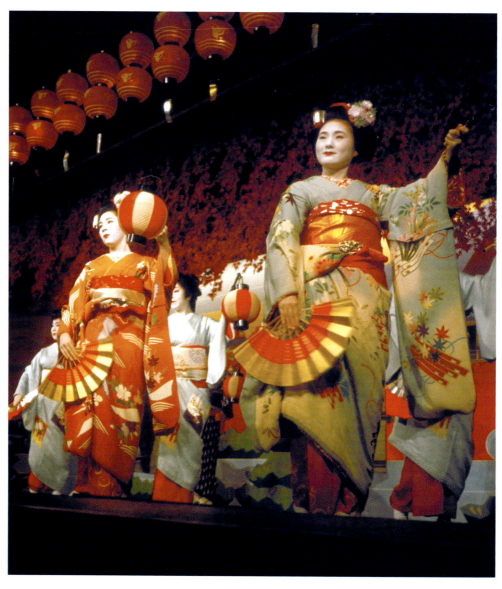

Japanese women dressed in kimonos participate in traditional performances.

WOMEN IN THE JAPANESE WORLD

In recent years, many Japanese have begun to celebrate Christmas, although few Japanese are practicing Christians. Stores are elaborately decorated and encourage people to exchange gifts. Japanese mothers may decorate their homes with a small tree and bake or buy a Christmas cake. As on Valentine's Day, also a recent introduction to Japanese culture, women and children give gifts to their friends and loved ones. Traditional exchanges of gifts are made at New Year's and the summer Obon festival.

Many holidays and rituals have special significance for women. On March 3, *hina matsuri* (the Dolls' Festival, also known as Girls' Day, *onna no sekku*), young girls receive a set of dolls, representing the emperor, the empress, and the royal family. The dolls are kept in a special cupboard until the week before the festival, when families admire them and eat special treats.

On November 15, *shichi-go-san*, girls who are ages three and seven are dressed in *kimonos* and go to their local shrine with their parents to pray for luck. (Boys age five go too; *shichi-go-san* means seven-five-three.) On the second Monday in January, women and men celebrate Coming-of-Age-Day, in Japanese *seijin no hi*. Communities have a celebration for young people who have turned twenty in the past year. Women wear traditional kimonos, and often have their portraits taken to be used for matchmaking applications, as it is considered a lucky day.

Weddings are a major event in women's lives. Elaborate superstitions are followed to determine a lucky date for the wedding, and traditional foods and gifts are exchanged. Weddings are usually **sanctified** by a simple Shinto or civil ceremony, because Buddhist rituals are associated with funerals.

Traditional wedding rituals emphasized the woman's **subservient** status to her husband. She wore a white robe, the color associated with death, to symbolize dying to her parents' family, and a red robe over that to signify her new birth as a member of her husband's family. She wore a headband over her elaborate hairstyle to cover "the horns of jealousy," implying that she should be selfless and obedient.

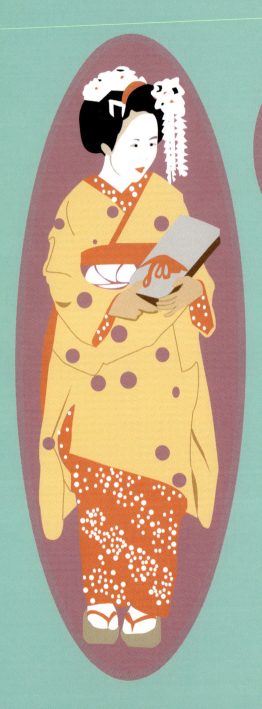

"ONCE WE HAVE BEEN AWAKENED, WE CAN NO LONGER FALL ASLEEP. WE ARE NOW LIVING. WE ARE AWAKE. OUR LIVES WILL NOT BECOME A REALITY WITHOUT GIVING FORTH SOMETHING WHICH IS BURNING INSIDE US." — HIRATSUKA RAICHO, 1913

## NOTABLE WOMEN

While Murasaki Shikibu's most famous work, *The Tale of Genji*, is a classic of Japanese literature and usually considered the world's first novel, we do not know when this lady of the Heian court was born or died, or even her real name, only that she lived somewhere around 1000 B.C.E. Details of **aristocratic** women's lives were not recorded in that time, although much of their beautiful and intelligent writing survives today.

Lady Murasaki's father was a scholar and held a position at the emperor's court. He was unusual in that he taught his daughter to read Chinese. She was briefly married to a man with several other wives. In her diary, she records her sense of frustration with the petty, competitive ways of court. She also felt mocked for her "unwomanly" love of books and learning.

As she served as lady in waiting to Empress Shoshi, Murasaki became famous among the courtiers for her writing, especially her fictional masterpiece, the *Tale of Genji*, completed around the year 1000. Her epic tales about Genji the Shining Prince describe the elaborate clothing and rituals expected of polite lords and ladies. The book also includes hundreds of poems.

Despite never holding an official office, Hojo Masako (1156–1225) was one of the most influential leaders in Japanese history. She married a rebel, Yoritomo no Minamoto, who had been a political prisoner of her father. Yoritomo eventually became the first ruling *shogun*, a military leader whose power surpassed the emperor.

After her husband's death, Masako became a Buddhist nun, but her real power was just beginning. Working with her powerful Hojo relatives, she controlled Japan through her son, the second shogun. Due to her influence, her son and her father were both *exiled*.

While remembered as a sometimes ruthless leader, Masako's merciful treatment of women prisoners was also noted. She is sometimes referred to as the "Nun Shogun," a tribute to the power she held "behind the scenes."

The father of Tsuda Umeko (1865–1929) thought he had too many daughters, so he volunteered six-year-old Ume to join a group of girls being sent to the United States as part of the Meiji regime's program to "westernize" Japan. Arriving in Georgetown, Maryland at age seven, she lived with an American *diplomat's* family for ten years and attended Bryn Mawr College. Upon her return to Japan, she worked as a teacher for fifteen years, and then in 1900 founded her own school, Joshi Eigaku Juku (Women's English School), later called Tsuda College.

Tsuda's main aim at the school was to teach women to speak English. She had been disappointed by the lack of practical skills being taught in the other women's schools, and wanted to ensure that her students graduated with skills that would enable them to earn an independent living. Ume herself refused to be married as a young woman and changed her name to "Umeko." However, she did not support most feminist causes, and tried to encourage her students to be patient and ladylike, following traditional and Christian ideals.

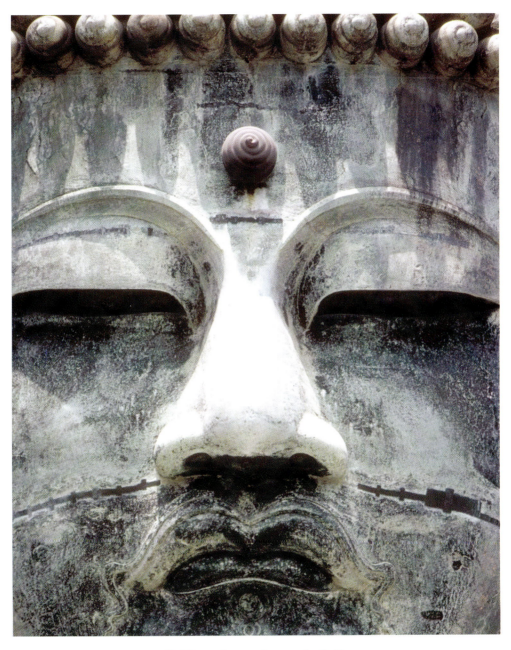

Buddhism influences Japanese family life.

Tsuda taught and served as principal of her school for many years, inspiring generations of young women. Many graduates went on to become teachers and feminist activists.

In an era when women were not allowed to vote or join political parties, Hiratsuka Raicho (1886–1971) was a brave and energetic advocate for women's rights. Hiratsuka grew up among the wealthy classes, studying literature and art. She was a lifetime follower of Zen Buddhism and was also influenced by European feminist thought.

She led several suffrage organizations and investigated the conditions of women in factories. In 1911, she founded a magazine for literary women, *Seito*, which published articles with "radical" ideas about women's rights. Her personal life was also different from acceptable standards: she had two children but never married.

Ridiculed in the media for years, many of her causes were finally made law in the 1946 Constitution. She continued to be active in working for world peace in her old age.

A graduate of Tsuda College, Ichikawa Fusae (1893–1981) helped to found the New Women's Association in 1920 and the Women's Suffrage League in 1924. While the suffragists were suppressed by the 1930s military government, Ichikawa eventually became a member of the *Diet*—and was reelected four times.

In later years, Ichikawa said her inspiration to work for women's rights was witnessing her father abuse her mother. Growing up on a farm, Ichikawa became a teacher and later was the first woman reporter for *Nagoya Shimbun* newspaper. She spent two and a half years in the United States, meeting with women leaders. She was first elected to the House of Councilors in 1953. Throughout her long career as a legislator, she was popular for her refusal to go along with party politics.

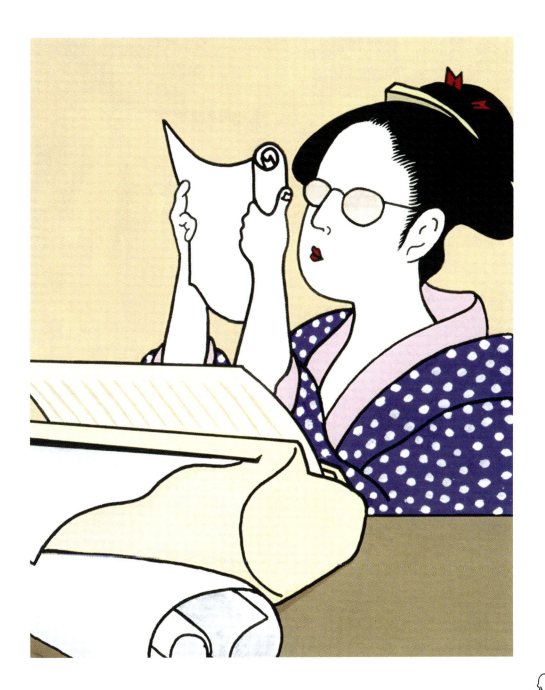

NOTABLE WOMEN

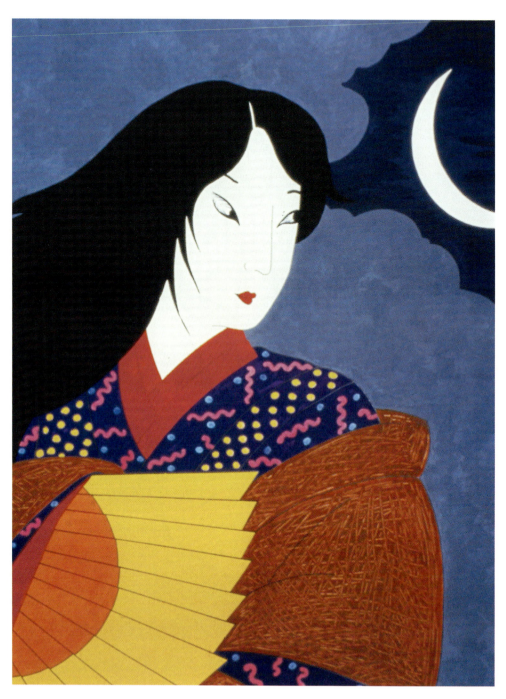

## THE STRUGGLE FOR SUFFRAGE

Many people assume that women's right to vote was "given" to Japan by the American occupation government, but women had been organizing, writing, and petitioning the Diet for decades. In 1910, Hiratsuka Raicho founded Seitosha, a "Bluestocking" society of literary women to promote women's issues. Her articles boldly addressed issues of suffrage, labor conditions, and a ban on prostitution. The society printed its own magazine, Seito, and many similar groups also were organized. The government censored Seito and banned it in 1916.

Women activists were often treated badly in public and ignored by the officials they hoped to influence. While men were skeptical about women's participation in politics after the war, over two-thirds of all women voted in 1946 and elected 39 women members of the Diet, more than in any election since.

While observers worldwide are disappointed by the small proportion of women in Japanese politics, there have been a few outstanding women leaders. Ogata Sadako has held high positions within the United Nations since 1976. Tanaka Makiko, daughter of a former Prime Minister, has served as Minister of Foreign Affairs since 2001 and is the only woman in the present Cabinet.

NOTABLE WOMEN

## ALIAS "TOKYO ROSE"

During World War II, thousands of Allied soldiers stationed in the Pacific tuned in their radios to a Japanese station with female, English-speaking djs. In between songs, they tried to demoralize their listeners, reminding them of the hardships of combat life and their certain defeat by the Japanese forces. However, the prisoners of war who were forced to write the shows' scripts tried to sneak in jokes and secret messages about Japanese troop movements.

Most of the listeners considered the shows entertainment, and referred to all of the female announcers as "Tokyo Rose." In 1949, a Japanese-American citizen, Iva Taguri, was convicted of treason for participating in the radio propaganda. She was sentenced to ten years in prison and a heavy fine. It was later admitted that anti-Japanese prejudice contributed to her prosecution, and in 1976 she was pardoned by President Gerald Ford.

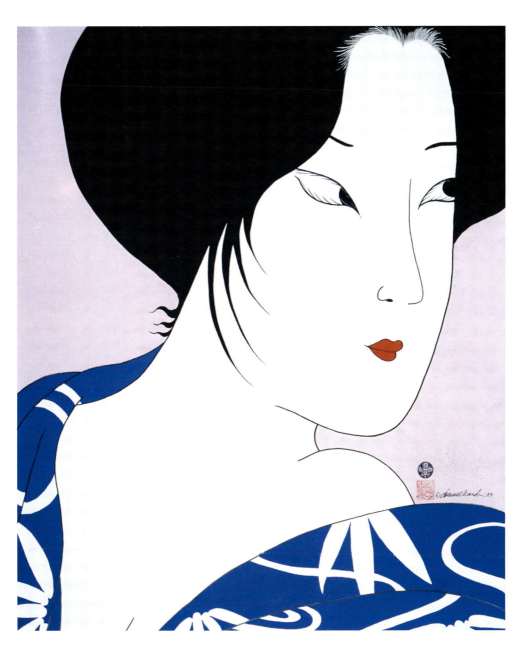

NOTABLE WOMEN

The daughter of a physician, Doi Takako (born 1928) attended Doshisha University and became a constitutional law instructor there. In 1969, she was elected to the House of Representatives as a member of the Social Democratic Party of Japan (SDPJ) and served seven terms. In 1986, she became the chairperson of the SDPJ, the first woman to have such a role. According to Japan's *electoral* system, this also made her a candidate in 1989 for Prime Minister, the highest elected position in Japan.

Doi's speeches reflected her personal optimism and made her very popular with women voters. She seemed like an ordinary woman, who enjoyed singing *karaoke* and even named her autobiography after her favorite song, "My Way." Although at first some political rivals implied that she would not be a good leader because she was not married, she continued to be chair of the party until 2003 and was speaker of the House of Representatives from 1991 to 1996. She had a great impact on her party's policies and also worked to expose scandals in the ruling party, the Liberal Democrats.

Famous for having married John Lennon, a former member of the Beatles, Yoko Ono (born 1933 in Tokyo) has continued to be an active and creative artist in the two decades after her husband's death. She was born into a very wealthy family in Tokyo but experienced many of the horrors of World War II. She attended college in Japan and the United States and married a Japanese-born musician. She had talents as a writer and music composer and was involved with the experimental art scene in New York City in the 1950s.

In 1962, she returned to Japan, divorced her husband, and married an American artist. They had a daughter, Kyoko. She eventually moved back to New York, where she created new interactive performance pieces, *conceptual* art, and film. While working in London, she met Lennon, who was an artist as well

The peace of a traditional Japanese garden is reflected in Yoko Ono's ideals.

NOTABLE WOMEN

as a world-famous musician. They were married in March 1969. In their collaborative art, they tried to spread a message of peace. Her interactive artwork and unusual films continue to be influential in the art world. She has also released several experimental and pop-music albums.

❁ ❁ ❁

Sasaki Sadako (1943-1955, Hiroshima) was only two years old when the nuclear bomb was dropped on Hiroshima. She seemed to be a healthy, normal girl until, at age eleven, she was diagnosed with *leukemia*. Many people around the bombed areas had gotten the disease as a result of the bomb. She endured the painful effects of leukemia with cheerfulness. In the hospital, she folded *origami* cranes out of paper. She believed an ancient legend that if she made a thousand of the cranes, she would get well.

NOTABLE WOMEN

Sadako continued to fold cranes until the day she died, on October 25, 1955. Her school friends collected her letters and published them as a book. Today, people from all over the world bring paper cranes to Sadako's memorial in Hiroshima Peace Park. She has become a symbol for not only the human cost of war, but the hope that peace will someday overcome it.

The daughter of a diplomat, Crown Princess Masako (born 1963) moved around with her father's job as a child and grew up in several different countries. She attended Harvard University, Tokyo University, and Oxford University, beginning a career working in Japan's foreign service in 1987. She married Crown Prince Naruhito, heir to the Emperor, in 1993. The media has placed immense pressure on her traditional duty to bear a male heir to the throne. In December of 2001, she gave birth to a daughter, Princess Aiko.

Princess Masako is only the second non-aristocrat to have married into the Japanese royal family. Some believed that her modern ideas would make her a very different kind of princess. While she enjoys some modern hobbies, like tennis and hiking, she also participates in traditional public events and ceremonies.

Like one of her famous characters, Takeuchi Naoko (born 1967) transformed herself from a nurse to the most successful female *mangaka* (comic book artist). Interested in art since childhood, Takeuchi earned a degree in **pharmacy** and worked in a hospital, drawing award-winning *manga* as a hobby. With her editors, she developed a series about a group of schoolgirls who are also magical crimefighters. The popular "Sailor Moon" series became a comic book and animated television series in 1992.

Manga is popular with men, women, and children of all ages in Japan. Although there are many "girl manga," which feature romantic teen situations,

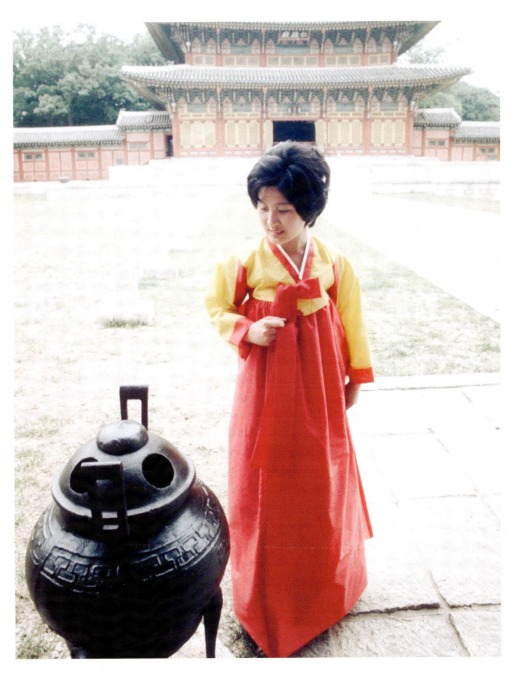

NOTABLE WOMEN

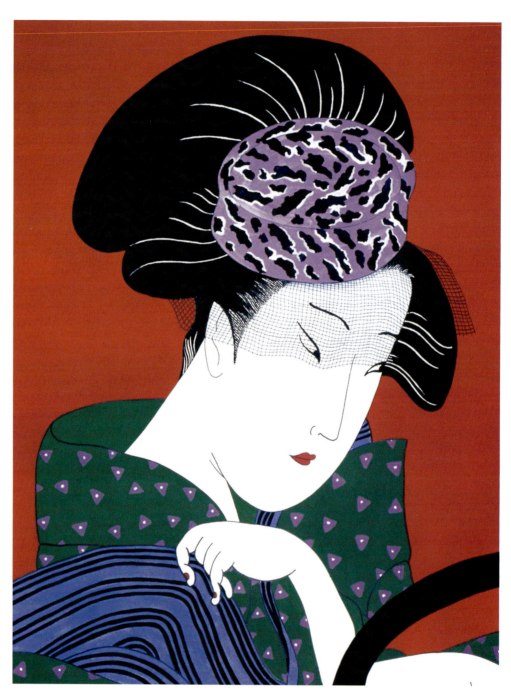

Takeuchi's Sailor Scouts were seen by many as a groundbreaking expression of female empowerment and positive role models for girls. "Sailor Moon" products and toys remain top sellers in Japan, and "Sailor Moon" cartoons are loved by fans around the world. With the success of this series, Takeuchi has become wealthy enough to "retire," but still draws manga occasionally.

Takahashi Naoko (born 1972) became the first Japanese athlete to win a gold medal in the track and field part of the Olympics. In 2000, she won the gold medal and set a record for the fastest women's time at the Sydney Games. She first came to prominence in 1998, winning the Nagoya Women's Marathon and a gold medal in the Asian Games. She has also had the fastest women's time in the Berlin Marathon of 2001 and 2002.

Her athletic achievement has made her a popular hero during a time of economic *recession*. She has been awarded the People's Honor Award by the Japanese government and received honors from her hometown and other cities. Since she turned professional in 2001, her image has advertised everything from sports drinks to newspapers. There is even a video game based on her. She is very popular in the media and is nicknamed "Q-chan." She continues to set records and compete in marathons around the world.

"I BELIEVE THE 21ST CENTURY IS THE CENTURY FOR THE WOMAN, AND IT IS FOR US TO ATTACK THE ISSUES."
—DOI TAKAKO, FORMER SPEAKER OF THE HOUSE OF REPRESENTATIVES, 2002

## ISSUES AND CHALLENGES

After a few months as a researcher in the newspaper office, Keiko had been promoted to being a reporter. The cherry trees were beginning to blossom in the city parks of Tokyo as she set out to conduct interviews for her first article. Her assignment was to ask women what they felt to be the most important issue facing them in the new century.

"I'm a lawyer," said one woman dressed in a business suit. "The most important goal should be ending *sexism* in the workplace."

Two schoolgirls giggled as Keiko asked them her question. "For us, the biggest challenge is passing the exam for the best high school!" one decided. "So we can get good jobs, like our parents want us to, and afford cool clothes."

An older woman wearing a kimono reflected for a moment. "Young women today are rude and *materialistic*: all they care about is buying expensive shoes and taking fancy vacations. They should pay more attention to their traditional duties as a woman."

A young woman walking with her boyfriend smiled. "I know my mother thinks the most important thing for me is to finish university and get married.

But I think the most important problem is ending *stereotypes* in the media. Sure, there are *anime* superheroes like Sailor Moon, but we need more real role models for girls. Women should know that they can do whatever they want."

The postwar constitution officially forbade many of the restrictive and emotionally damaging traditions that had limited women, but changing centuries of traditional beliefs takes more than a law. Feminist leaders are frustrated by women's perceived reluctance to fight stereotypes in the media and sexism in the workplace. In 1994, the Council on Gender Equality was formed within the Japanese Cabinet to address topics that affect women, such as prostitution, spousal abuse, and maternity leave. Each year, they release a "White Paper" detailing goals for the upcoming year to help make Japan a gender-equal society.

Feminist groups have been active since the early twentieth century. Organizations for women's suffrage were followed in the 1970s by groups inspired by the "women's liberation" movement in the United States. In 1976, the United Nations declared a worldwide "Decade of the Woman." Several laws that supported women's welfare were passed during this period, culminating with the 1986 Equal Employment Opportunity Law. In the same year, Doi Takako became the first woman to chair a major political party and was a candidate for Prime Minister.

There are still few women in public office. Not one of Japan's forty-seven *prefectures* (provinces) is governed by a woman. As of March 2003, only 72 of the Diet's 727 members were female. But women contribute to important causes in other ways. Mothers make up the Parent-Teacher Association (PTA), a very influential organization in Japan. They are also active in political movements on issues such as nuclear *disarmament* and environmental protection. Neighbor-hood groups are influential on consumer issues.

The historical perception of men's superiority continues to be felt even under Japan's gender-equal goals. It is believed that many crimes against

## THE AMERICAN INFLUENCE

During the Meiji period, many Japanese men emigrated to Australia and the western United States in search of jobs. They exchanged photographs with young women in Japan, who came as "picture brides" to marry them. Many immigrant Japanese women worked as domestic servants.

After World War II, thousands of servicemen from the United States, Australia, and the United Kingdom married Japanese women, usually without their parents' consent, and brought them home as "war brides." Some women were glad to travel and assimilated to their new home. Others were disappointed by their isolation in a strange country. The United States maintained a military base on Okinawa for much of the twentieth century, and thousands more Japanese women married American military personnel. The national status of the hundreds of Amerasian children born to American soldiers and unmarried Japanese women has remained an unsolved issue.

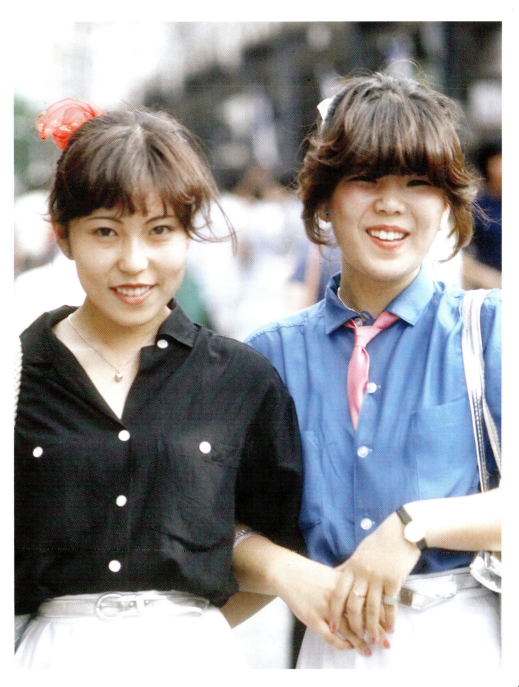

ISSUES AND CHALLENGES

Japanese women are often portrayed as sex objects.

women go unreported because of shame. Wives who are mentally or physically abused by their husbands feel that they should not risk dishonor for the family by seeking a divorce, but these attitudes are slowly changing. For example, the divorce rate has nearly doubled in the last twenty years, and women's crisis centers have been established in most cities. In 2001, the government passed a "Law for the Prevention of Spousal Violence and Protection of Victims."

Advertising and the media often portray women in traditional roles as mothers or as providers of sexual gratification for men. Particularly troublesome is the media's *exploitation* of young girls. Magazines, some comic books (*manga*), and advertisements in public places like commuter trains often show women in skimpy clothing. Pornography can be purchased from sidewalk vendors or machines. Fashion "fads" also encourage young women to dress in provocative ways.

There is little effort to combat this disturbing trend. Prostitution was declared illegal in 1956, but additional laws with more specific protection for young women continue to be proposed. Many women are the victims of "train perverts" who take advantage of crowded subway cars to grope them. Young girls are recruited in advertisements to become part-time "entertainers" in cities' sex districts. Sometimes they are kidnapped or abused. There is also little official protection for the thousands of young women brought to Japan from other Asian countries to be "exotic dancers" or prostitutes. Human Rights Watch, an international organization, recommends that Japan be considered seriously at fault for its failure to protect women who are *trafficked* this way. In addition, Japanese men's "sex tourism" exploits poor women in countries like Thailand and the Philippines.

Another issue is discrimination against minority women. Because the population is 98 percent ethnically Japanese, people who look "different" are easy to notice, and the conformist mindset makes many people act cruelly toward those

ISSUES AND CHALLENGES 97

they perceive as foreign or of mixed background. The United Nations has cited Japan for discrimination in schools and jobs against non-Japanese, the ethnic *Ainu* people, and so-called *burakumin* outcasts. The children of Japanese fathers and the new "immigrant brides" in farming communities also are treated harshly.

While much fuss is made in the West about "liberating" women from housework, in recent years many people in Japan have begun to regard overworked, stressed-out men as the victims of social expectations. "Death by overwork" is becoming a serious issue, which naturally has an effect on the families of ill or untimely deceased husbands and fathers. Heart disease, exhaustion, and other health problems are beginning to afflict working women as well as men, from executives to factory workers.

The high level of stress associated with Japan's competitive culture in schools and families has been brought to wide attention in tragic incidents. One mother killed a neighbor whose noise, she thought, was bothering her son as he studied for exams. Another murdered a two-year-old girl because, she said, the girl's mother was so critical at the playground. A majority of teenagers, girls and boys, report feeling very stressed by their parents' expectations. Some turn to drugs or fall into depression.

The cultural division between men's and women's roles still poses unique challenges to women in the workplace. Despite recent laws, sexual harassment on the job and pressure on women to retire at a young age continues. Lawmakers, employers, and workers disagree about maternity leave and other benefits for working mothers. About half of all working women are *pato*, temporary or part-time workers, although they work as many or more hours as full-time employees for fewer benefits. In the recent downturn of the economy, thousands of part-time workers have been laid off, many of them women who work in manufacturing.

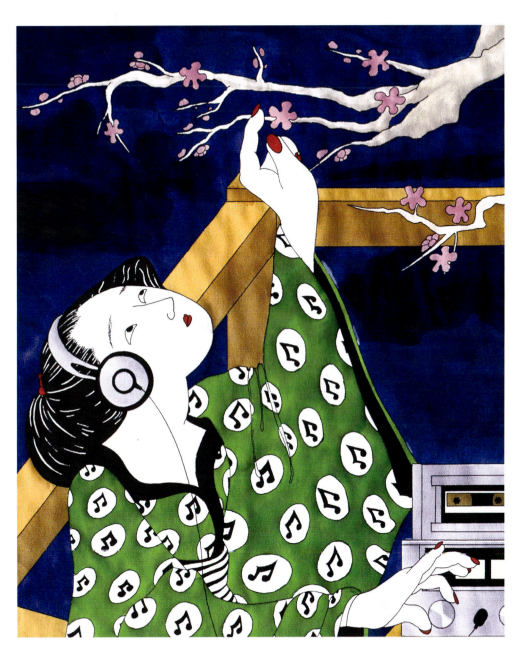

ISSUES AND CHALLENGES

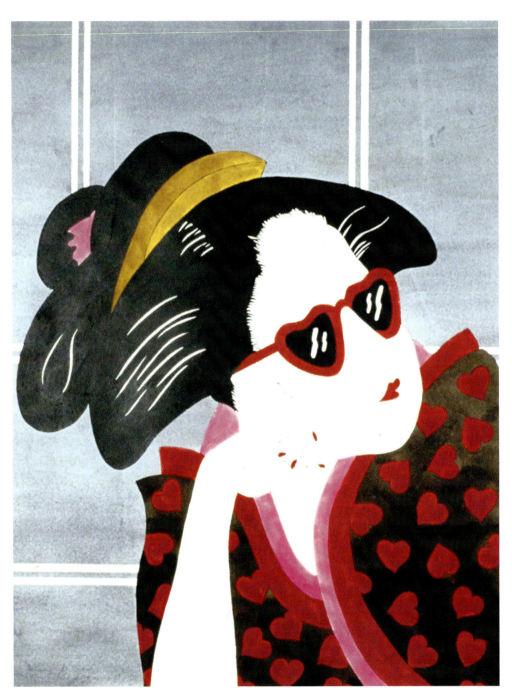

WOMEN IN THE JAPANESE WORLD

Many traditional patterns of family life are changing. In recent years, women's expectations of their future spouses have been different from the old saying that "a good husband is healthy and absent." They want a partner who shares their interests and will help more equally with housework. Women are content to spend years looking for an ideal partner themselves, rather than relying on an arranged match. As of 2001, the average age of women at their first marriage was over twenty-seven. It is also becoming more acceptable for women to live with their boyfriends or raise children with a partner without being married.

According to the 2000 census, the percentage of women who remain unmarried keeps increasing. Many women do not marry until their thirties, when they may decide not to have children at all. These two factors allow women to have much more *disposable income*, money to spend on themselves. Shopping is a major leisure activity, and urban women are eager to buy expensive clothes and accessories from top European designers. Gambling at *pachinko*, a pinball-type game, is an expensive but popular hobby for men and women.

Some view this trend as a problem. They say that women who choose not to marry are taking advantage of their parents' care and shirking their duties as a woman. Changing social patterns also have an effect on older women. As the life expectancy continues to rise, many women who had to endure the domination of a *mama-san* in their early married life find they cannot expect the same sort of support from their own children. Mothers continue cooking and cleaning for their grown children who live at home. As more mothers work outside the home, more grandmothers are called into service as baby-sitters. While their husbands can retire from their work, a woman's "eternal employment" extends to caring for her husband after his retirement. Since the older generation has more traditional values, she is expected to keep up with cleaning, serving him, and keeping him company as long as she is well enough to do so.

# GLOSSARY

*apprenticeship* A prescribed period of time where one is bound by indenture (formal contract) to serve another to learn an art or trade.

*aristocratic* Belonging to, having the qualities of, or favoring government by a small privileged class.

*conceptual* Of, relating to, or consisting of abstract or generic ideas generalized from particular instances.

*depopulation* Great reduction of a population.

*Diet* Any of various national or provincial legislatures.

*diplomat* One employed or skilled in the art and practice of conducting negotiations between nations.

*disarmament* The giving up or reduction of weapons.

*disposable income* Income remaining to an individual after the deduction of taxes and paying of bills.

*electoral* Of or relating to one qualified to vote in an election.

*eugenics* A science that deals with the improvement (as by control of human mating) of hereditary qualities of a race or breed.

*exiled* Banished or expelled from one's own country or home.

*exploitation* An act or instance of taking advantage of someone or something for one's own advantage.

*feminists* Those promoting the theory of the political, economic, and social equality of the sexes.

*flappers* Young women of the period of World War I and the following decade who showed freedom from conventions (as in conduct).

*industrialization* The act of organization in which industries, especially large-scale industries, are dominant.

*integrated* Not segregated; having equal membership.
*karaoke* A device that plays instrumental accompaniments for a selection of songs to which the user sings along and that records the user's singing with the music.
*ladies-in-waiting* Ladies of a queen's or a princess's household appointed to wait on her.
*leukemia* An acute or chronic disease in humans and other warm-blooded animals characterized by an abnormal increase in the number of white blood cells in the tissues and often in the blood.
*materialistic* The state of being preoccupied with or stressing the material rather than intellectual or spiritual things.
*meditation* Contemplation and reflection.
*occupation* The holding and control of an area by a foreign military force.
*peasant* A member of a class of persons (usually uneducated and of low social status) tilling the soil as small landowners or as laborers.
*pharmacy* The art, practice, or profession of preparing, preserving, compounding, and dispensing medical drugs.
*rationed* Distributed sparingly and equitably.
*recession* A period of reduced economic activity.
*sanctified* Set apart for a sacred purpose or religious use; consecrated; free from sin.
*sects* Groups adhering to a distinctive doctrine or to a leader.
*service industries* Industries which do not manufacture a product but provide a service (as banking or tourism).
*sexism* Prejudice or discrimination based on sex, especially discrimination against women.
*shamans* Priests or priestesses who use magic for the purpose of curing the sick, divining the hidden, and controlling events.
*shrines* Places at which devotion is paid to a saint or deity; sanctuaries.

GLOSSARY

*stereotypes* Things conforming to a fixed or general pattern, especially standardized mental pictures that are held in common by members of a group and that represent oversimplified opinions, prejudiced attitudes, or uncritical judgments.

*subservient* Useful in an inferior capacity; subordinate.

*subsistence farming* A form of farming where the land provides most of the necessities of life (food, fuel, and shelter). Tools and other items that cannot be generated this way are acquired through surplus trading.

*taboo* Banned on grounds of morality or taste.

*traditional* Of or related to an inherited, established, or customary pattern of thought, action, or behavior (as religious practice or a social custom).

*trafficked* Bartered or bought and sold.

# GLOSSARY OF JAPANESE WORDS

Note: Many words new in the Japanese language, like *sarariman* (salaryman) *pato* (part-time) and *moga* (modern girl) are adapted from English. There are often a variety of ways to translate Japanese words into Roman letters. The word for tea ceremony, for example, can be written *sado*, *shado*, or *chado*. Also, plural forms are usually written in English the same as singular.

*Ainu* Ethnic group indigenous to Hokkaido.
*anime* Animated films or television shows.
*bikuni* Wandering nuns of the Middle Ages who used stories and songs to teach Buddhist ideas.
*burakumin* Descendants of outcast families who traditionally performed "unclean" tasks.
*-chan* Diminutive used on the ends of women's and children's names.
*daimyo* Feudal landowners during the Middle Ages.
*eikyu shushoku* "Eternal employment"; the state of being a wife and mother.
*geisha* "Arts person"; any celebrity courtesan and entertainer who lived in the arts districts of cities beginning in the 1600s.
*hina matsuri* Dolls' Festival, March 3, when dolls of the imperial family are displayed and prayers are said for young daughters of the household
*ie* household; nuclear family; family line.
*ikebana* Traditional flower arranging begun as Buddhist art; popular hobby.
*juku* "Cram school"; after-school classes to prepare for entrance exams.
*kimono* Traditional silk robe worn by women on special occasions.
*koto* Traditional stringed instrument played by placing on the floor and plucking.

*mama-san* Mother-in-law.
*manga* Comic book.
*mangaka* Comic book artist.
*miko* Female Shinto priestess or shrine assistant.
*mizugo* Small statue left at a Buddhist shrine in memory of deceased children or fetuses.
*moga (pl. mogu)* "Modern girl"; media term of the 1920s to describe women who adopted western fashion and tastes.
*obi* Stiff, wide sash used to tie kimono.
*okaasan* Mother.
*office lady* (O.L.) Women who perform secretary-like tasks in offices.
*onna no sekko* Girl's Day, March 3; national holiday to pray for girls of the household.
*origami* Art of folding colored paper into the shape of animals and other things.
*pachinko* Popular pinball game played for money.
*pato* "Part-time"; arrangement of employment which may be temporary or for shorter hours than full-time work, but always with fewer benefits and less job security.
*ronin* Samurai not attached to a *daimyo*.
*ryosai kenbo* "Good wife and wise mother"; ideal for women promoted by the government and media during the Meiji Restoration.
*sado* Formal tea ceremony.
*sarariman* "Salary-man": stereotype of commuting, overworked city employee.
*samishen* Four-stringed guitar-like instrument popular among geisha.
*samurai* Feudal warriors who obeyed a strict code of honor.
*-san* Formal name ending showing respect (like "Mr." or "Ms." in English).
*seijin no hi* Coming of Age Day, second Monday in January; celebrates twenty-year-old women and men who have reached legal adulthood.

*seppuku* Ritual suicide by stabbing.

*shichi-go-san* "Seven-five-three"; on this holiday, girls who are ages three and seven and five-year-old boys go to local shrines to pray for luck.

*shodo* Calligraphy done with ink and brush.

*shogun* One of many military leaders who virtually ruled Japan parallel with the emperor, beginning with Minamoto no Yoritomo and ending with the return of the imperial line to supreme power in 1868.

*taiko* Large, loud drums played at festivals.

*tatami* Woven mats, traditional covering for interior floors.

*tenno* Emperor or supreme ruler, male or female.

*tofu* Protein-rich soybean curd.

*ukiyo-e* "Pictures of the floating world"; woodblock prints depicting geisha, entertainment, and city life during the Edo period.

*Zen* Type of Buddhism that emphasizes meditation.

# FURTHER READING

Bowring, Richard, translator and editor. *The Diary of Lady Murasaki.* New York: Penguin Books, 1996.

Coerr, Eleanor. *Sadako and the Thousand Paper Cranes.* New York: Puffin Books, 1999.

Hammond, Paula and Robert Lee Humphrey. *China and Japan: Cultures and Costumes.* Philadelphia, Penn.: Mason Crest, 2003.

Houston, Jeanne Wakatsuki and James Houston. *Farewell to Manzanar: A True Story of the Japanese American Experience During and After the World War II Internment.* New York: Bantam Books, 1993.

Morris, Ivan, translator and editor. *The Pillow Book of Sei Shonagon.* New York: Columbia University Press, 1991.

Ozaki, Yei Theodora. *The Japanese Fairy Tale Book.* Boston: Tuttle, 1990.

Rose, Barbara. *Tsuda Umeko and Women's Education in Japan.* New Haven, Conn.: Yale University Press, 1992.

Uchida, Yoshi. *The Invisible Thread.* New York: Beech Tree, 1999.

# FOR MORE INFORMATION

Japan Information
sunsite.sut.ac.jp/asia/japan/
Pictures and links to a variety of sites about Japanese culture.

Japan Today
www.japantoday.com
Daily updated translations of news, cultural information, and opinion polls.

Japan Zone
www.japan-zone.com
Source of information on Japanese traditions, history, famous figures, and current popular culture.

Kids' Web Japan
www.jinjapan.org/kidsweb/
Young person's guide to Japanese facts and culture, with fun activities to try from your computer.

Publisher's note:
The Web sites listed on this page were active at the time of publication. The publisher is not responsible for Web sites that have changed their addresses or discontinued operation since the date of publication. The publisher will review and update the Web sites upon each reprint.

# INDEX

America (United States) 18, 19, 21, 28, 38, 44, 66, 69, 74, 76, 79, 93, 94
arranged marriage (and matchmaking) 17, 28, 37, 38, 41, 47, 71, 101
arts (traditional women's) 59, 60, 63, 64, 66, 67, 85

behavior and customs (of women) 11, 15, 17, 18, 19, 27–30, 38, 42, 47, 49, 50, 54, 57, 60, 63, 71, 101
Buddhist (Zen Buddhism) 11, 17, 59, 63, 64, 66, 71, 74, 75, 76

caligraphy (shodo) 59, 63, 64
careers (jobs, work, for women) 17, 18, 19, 21, 25, 27–30, 32, 38, 42, 47, 49–51, 53, 54, 57, 98
China (Chinese) 11, 15, 21, 60, 63, 66, 73
Christian (Christianity) 17, 69, 71, 74
Confucius (Confucian influences) 12, 15, 27, 28, 66
constitution (new, postwar) 23, 76, 93
Council on Gender Equality 93

daimyo 15, 17, 18, 60
Decade of the Woman 93
Doi Takako 82, 90, 93

education (school) 47, 49, 50, 53, 74 98
emperor 12, 15, 17, 18, 23, 42, 73
Equal Employment Opportunity Law (EEOL) 53, 54, 93

Eugenics Protection Law 30
Europe (European) 17, 18, 101

festivals and holidays 66, 71

geisha 60, 62, 63, 66
Go-Sakuramachi 12

Haru Ko 12
Hiratsuka Raicho 10, 48, 72, 76, 79
Hojo Masako 74
home, Japanese (modern customs and furniture) 44, 45, 46, 59, 61, 66
Human Rights Watch 97

Ichikawa Fusae 76
ikebana (flower arranging) 59, 63

Japanese Labor Standards Law 53

kimono 59, 62-64, 66, 69, 70, 71

Law for the Prevention of Spousal Violence and Protection of Victims 97
Loyal Ronin, The 17

marriage 17, 25, 27, 28, 30, 37, 38, 41, 42, 47, 49, 50, 54, 69, 71, 94, 97, 101
Masako, Crown Princess 86
Meiji 12, 18, 23, 28, 38, 50, 74, 94
Meisho 12
Minamoto no Yoritomo 15
Murasaki Shikibu 15, 50, 73

110  INDEX

Nagoya Shimbun 76
Naruhito, Crown Prince 86
Naruhito, Princess Aiko 86
New Women's Association 76

Ogata Sadako 79
Ono, Yoko 82, 83, 85

Parent-Teacher Association (PTA) 93
People's Honor Award 89
Perry, Commodore Matthew 17
Pillow Book, The 15
politics (laws and rights effecting women) 19, 23, 27, 38, 50, 53, 54, 57, 60, 76, 79, 93, 98
prostitution 18, 21, 60, 79, 93, 97

reproduction (birth control and pregnancy) 30, 47

"Sailor Moon" 86, 89, 93
samurai 15, 17, 18, 60
Sasaki Sadako 85, 86
Sei Shonagon 15

Seito (magazine) 10, 76, 79
Shinto (religion) 11, 17, 66, 69, 71
shogun 15, 17, 74
Social Democratic Party of Japan (SDPJ) 82
suffrage 76, 79, 93
suicide 15, 17, 28, 38

Taguri, Iva 80
Takahashi, Naoko 89
Takeuchi Naoko 86, 89
Tale of Genji, The 15, 73
Tanaka Makiko 79
tea ceremony (sado) 60, 64, 66
Tokugawa Ieyasu 17
Tokyo Rose 80
Tsuda College (Joshi Eigaku Juku, Women's English School) 36, 74, 76
Tsuda Umeko 36, 74, 76

World War II 21, 27, 28, 50, 80, 82, 94

Yoritomo no Minamoto 74

# PICTURE CREDITS

Artville: pp. 16, 26, 33, 40, 52, 55, 56, 77, 78, 81, 88, 92, 99, 100. Corel: pp. Front cover, 13, 14, 19, 22, 29, 31, 34, 39, 43, 45, 46, 51, 61, 65, 67, 68, 70, 75, 83, 84, 85, 87, 95, 96, 99. PhotoDisc: Front cover. Photos.com: 62.

# BIOGRAPHIES

Elizabeth Van Houten is a graduate of Smith College. She has lived in New York, Los Angeles, and London. This is her first book.

    The author would like to thank Akiko Crawford, Dr. Robert Eskildsen, Yuriko Hikida, Ji Eun Lee, Autumn Libal, Kana Okana, Keiko Omuri, and Aya Ueyhara for their contributions to her research.

Dr. Mary Jo Dudley is the director of Cornell University's Gender and Global Change Department, which focuses on the evolving role of gender around the world. She is also the associate director of Latin American Studies at Cornell.